French Paintings

The publication of this catalogue was made possible, in part, by a grant from the National Endowment for the Arts, a federal agency in Washington, D.C., through the generosity of Mr. and Mrs. Paul Mellon, and by a research and editorial grant from the Andrew Mellon Foundation.

FRENCH PAINTINGS

*The Collection of Mr. and Mrs. Paul Mellon
in the Virginia Museum of Fine Arts*

by PINKNEY L. NEAR

Introduction by JOHN REWALD

VIRGINIA MUSEUM OF FINE ARTS · RICHMOND

Distributed by the University of Washington Press, Seattle and London

Virginia Museum of Fine Arts, Richmond, Virginia 23221

© 1985 by the Virginia Museum of Fine Arts. All rights reserved.

Printed in the United States of America.

LIBRARY OF CONGRESS CATALOGING-IN-PUBLICATION DATA

Virginia Museum of Fine Arts.
 French paintings.
 Includes index.
 1. Painting, French—Catalogs. 2. Painting, Modern—19th century—
France—Catalogs. 3. Painting, Modern—20th century—France—
Catalogs. 4. Mellon, Paul—Art collections—Catalogs. 5. Mellon,
Paul, Mrs.—Art collections—Catalogs. 6. Painting—Private collections—
Virginia—Richmond—Catalogs. 7. Virginia Museum of Fine Arts—
Catalogs. I. Rewald, John, 1912– . II. Near, Pinkney L. III. Title.
ND547.V55 1985 759.4'074'0155451 85–21703
ISBN 0–917046–20–X
ISBN 0–917046–19–6 (pbk.)

COVER: Edouard Manet, *On the Beach, Boulogne-sur-Mer*, 1869 (cat. no. 27).

CONTENTS

FOREWORD

For nearly as long as this Museum has existed it has counted Paul Mellon as one of its principal benefactors. An early believer in and lifelong member of the Museum, Mr. Mellon became a Trustee in 1938 and served in that capacity for forty years. Being convinced that the arts were not single-faceted, and in 1954, realizing the growing need in central Virginia for a permanent resident theatre, he funded a major portion of the Museum's second wing, which included a new 500-seat theatre.

Throughout the intervening years he continued to manifest interest in the Museum's activities. In 1960 he made loans from his extraordinarily rich and varied collection of English eighteenth- and nineteenth-century sporting paintings to the memorable exhibition *Sport and the Horse*, and in 1968 he underwrote the acquisition of a collection of Indian art that has few rivals in its excellence and comprehensiveness.

These evidences of confidence in our purpose alone would have earned the indebtedness and gratitude of the Museum and of the Commonwealth to which it belongs. Yet recently Mr. Mellon and his wife, Rachel (Bunny), have gone further. First, they loaned a selection from their superb collection of nineteenth- and twentieth-century French art, a collection that is especially strong in the Impressionists. They then donated these works to the Museum, simultaneously adding several objects of signal importance. More recently Mr. Mellon added an important collection of English eighteenth- and nineteenth-century sporting paintings, drawings, and prints as well as American sporting and genre paintings.

Lastly, in order to assure that these resources would be displayed in an environment worthy of their quality, the Mellons enthusiastically subscribed to the imaginative scheme of joining forces with Sydney and Frances Lewis to underwrite a substantial part of the construction costs of the Museum's new West Wing, the inauguration of which this catalogue celebrates.

The history of the Virginia Museum of Fine Arts is testimony to the compact between private philanthropy and enlightened government, each contributing their rightful part—one sensing its obligation to share its resources with society, the other recognizing that museums are essential components of the community's cultural well-being.

The paintings discussed and illustrated in these pages represent a broad cross-section of French creativity at a critical point in the evolution of French taste and the emergence of a new social order. We are fortunate that this fascinating chapter in the history of art is represented by objects of such high quality and that they are shown in an environment of such monumental design, which can only enhance our appreciation of their subtlety.

Grateful as we are for these gifts, generations to come will be even more thankful as they find here irreplaceable testimonies of artistic vision, personal accomplishment, and civic generosity.

PAUL N. PERROT
Director,
Virginia Museum of Fine Arts

INTRODUCTION

From the legendary and seemingly bottomless cornucopia that constitutes the collection of Mr. and Mrs. Paul Mellon splendid gifts have poured towards the museums that are close to the benefactors' hearts. These institutions are the National Gallery of Art in Washington, D.C., built for the nation by Andrew W. Mellon, Paul Mellon's father; Yale University in New Haven, Connecticut, Mr. Mellon's alma mater, whose museum of art not only benefits from his munificence, but where he has also established the Center for British Art, unique in this country; and finally, the Virginia Museum of Fine Arts in Richmond, not far from Mr. and Mrs. Mellon's main residence in Upperville, Virginia. Sometimes a single masterpiece is given, sometimes a whole group of works is presented. The recent gift to the Richmond institution is the subject of this publication, issued on the occasion of the dedication of the new West Wing. Indeed, the Mellon generosity has also provided part of the funds for the new wing, where most of their Impressionist paintings will continue to be displayed.

Paul and Rachel (Bunny) Mellon have never been "systematic" collectors; they were interested neither in filling gaps in the institutions they favored nor in assembling a "balanced" representation of any specific movement or artist. They made the widest possible use of their privilege as private collectors, which is to acquire whatever they liked, what attracted them, and what promised pleasure. By the same token they have on occasion also renounced whatever disappointed them over the long run. Yet, what they lacked in system they made up in selection: they are not easily pleased and always reach for the exceptional. It is symptomatic, for instance, that over the years they have owned exactly a dozen paintings by Cézanne; of these, five have been given to museums, one was traded for a more important work, another was sold, and five still belong to them. The remaining five are not necessarily the most outstanding of the original group (though among them are at least two breathtaking pictures); some equally important works have been given away, among them the beautiful portrait of Victor Chocquet that now hangs in the Richmond museum.

Although there is a certain element of flux surrounding the Mellon collection, one thing has remained stable: with the exception of the British and American works it is devoted essentially to French art of the nineteenth and twentieth centuries. This represents a fairly wide span, from Théodore Géricault and Camille Corot to Pablo Picasso and Nicolas de Staël. And within this wide range there have been favorites—such as Eugène Boudin, Pierre Bonnard, Edgar Degas, and Vincent van Gogh—as well as artists who were almost totally neglected if not overlooked altogether. Thus, when the time came to select a group of paintings for the Virginia Museum (and a large group it is), there was an incredible reserve to choose from.

Late in life Félix Fénéon, the French Symbolist writer and friend of many artists, foremost among whom was Georges Seurat, declared that he had reached a stage where the only joys he could obtain from many of his possessions was to give them away. If those close to him protested his gifts or hesitated to accept them, he would say with a smile that appeared slightly pained, "You can't really mean to deprive me of the last pleasure I can still derive from this object," thus turning acceptance of his gifts into doing him a favor. Mr. and Mrs. Mellon are far from having reached Fénéon's "give-away" period, yet they, too, have discovered already years ago that the satisfaction of acquiring

and possessing a work of art can be reanimated by the selfless gesture of giving it away. The result is a twofold blessing whereby the donor is probably as happy as the recipient.

The Mellons' gifts are of course different from Fénéon's private offerings insofar as their donations go exclusively to public institutions and thus benefit the entire art community. And that, again, is even more praiseworthy than may appear at first glance. Following the example of Paul Mellon's father, Andrew Mellon, who did not permit his name to be bestowed on the museum he built for the nation, nor require that his own collection be enshrined in a setting where nothing else could be tolerated, Paul and Bunny Mellon have eschewed keeping their pictures and sculptures together in a building that could have taken pride of place among many similar institutions in America; they have actually "destroyed" their collection by splitting it up among several museums, giving to each what would be best suited to its purpose. The Virginia Museum of Fine Arts is among the fortunate recipients of the Mellon treasures. At the same time that this massive enrichment confers considerable prestige upon the Museum it also produces—as a possibly unexpected result—a challenge, and new goals, which require filling in the gaps quite unintentionally created by the Mellon gift. This is comparable to the conditions for matching contributions that nowadays are so often attached to donations. Although in this case there are no stipulations of any kind, it is obvious that the Museum's funds should henceforth be directed to those periods or aspects that still need strengthening.

For instance, it is evident that between the group of extremely fine and typical works by Boudin (among them, one of those lovely studies of clouds that Baudelaire admired) and an unusual series of poetic views of Paris by Stanislas Lépine (among which there is a rare painting with a superb group of houses at La Bièvre), there is room for at least one canvas by their contemporary Corot, and this the more so as there are also significant works by other fine landscapists of the period, such as Johan Barthold Jongkind and Henri-Joseph Harpignies. On the other hand, Edgar Degas is represented by two splendid portraits and an important painting of racehorses which together provide some of the essential aspects of his genius. Yet, if any patriotic Virginian took the Mellon example to heart and decided to add a fine pastel or oil of Dancers to this group, the benefit to the Museum, the public, and Degas would be considerable.

Among the unusual features of the Mellon gift is the fact that some famous artists are shown by rare early works in which not even the initiated may be able to recognize their brush, such as the Manet-inspired still life by Paul Gauguin, which combines with its intrinsic qualities as a fine painting an intriguing stubbornness that refuses to yield any clues to the personality that was to emerge from this first step. Of similar character are the two tropical landscapes by Camille Pissarro reflecting the setting in which he grew up in his native Saint Thomas in the Virgin Islands; there is, in addition, a later, extremely delicate and more typical work. For Alfred Sisley, too, there are works of widely different periods: an early and surprising still life (one of the very few such subjects he ever treated), a second delicate and later still life, this one of wildflowers (the only one of its kind Sisley ever painted), a rather solidly executed view of the Thames at Hampton Court, and an iridescent landscape of 1876.

It seems superfluous to point out that Picasso's many creative phases could almost represent as many different artists. His three paintings in the Mellon gift are completely dissimilar in style. The most appealing and possibly the most important among them is the *Jester on Horseback* (also known as *Harlequin on Horseback*), a work from the artist's so-called Pink Period during which the circus world in general and jesters and harlequins in particular were among his favorite subjects. Here, in an undefinable mixture of tragic loneliness and tender grace, a black horse and a youth clad exclusively in red strike the imagination through

the simplicity and monumentality of the color scheme and the composition.

Vincent van Gogh's two small paintings represent two crucial phases of his evolution. The brightly colored *Bathing Float, Paris* with its drastic foreshortening reflects his encounter with Impressionism, whereas the somewhat agitated field at Saint-Remy—painted only a couple of years later—reveals his struggle with animated forms and deep emotions. Both of these paintings, despite, or because of, their modest size, are real gems.

Flowers are the main features of the two paintings by Claude Monet. There are the glowing fields of poppies at Giverny, a literal hymn to summertime, and there is the splendid painting in which his wife, Camille, appears behind an open window at Argenteuil with the entire lower half of the picture invaded by a glorious profusion of blossoms. (The fact that Mrs. Mellon is a passionate and renowned gardener probably accounts for the presence of these works, as well as for that of flower still lifes by Alfred Sisley, Henri Fantin-Latour, Georges Braque, and Edouard Vuillard.) Berthe Morisot is richly represented in this group of works by her colleagues and contemporaries. Along with two elongated seaside views of an unusual format that Morisot occasionally favored and within the rectangles of which she established admirable compositions treated with a light brush, there is a typical figure piece of a woman seen from the back whose deftly treated white dress is beautifully accented by a slim black ribbon hanging from her neck. The woman is watering a plant on her roof garden, and this may again be a reflection of Mrs. Mellon's special interest.

Morisot's friend Auguste Renoir appears here with two particularly well-chosen canvases: a woman perceived from the back, her head half resting on a delicate hand and turned to reveal a lovely profile. The various elements of this work seem to vie for the onlooker's attention: the beauty of the young woman (one of Renoir's favorite models), the fluency with which her rich blond hair is rendered in a multitude of nuances, the lively brushwork and texture of the greenery in the background, scintillating in the sun. This canvas of 1875—one of the periods of Renoir's most felicitous work—is complemented by a likeness of the artist's son Jean created a quarter of a century later, where the vibrancy of the earlier picture has been replaced with a soft modeling that produces simple volumes remindful of sculpted forms.

The *douanier* Rousseau is represented in the group by only one picture, but this is a superb work, one of the artist's large and fascinating tropical landscapes. It has the added interest of showing a ferocious ape struggling with—of all things—an American Indian (or what the artist imagined to be one). This is a highly typical example of Rousseau's treatment of wholly invented jungles with their repetitious and superimposed leaf patterns, each plant neatly set out against its neighbors, the whole dominated by an intensely red sun. The work is dated 1910, the year in which the *douanier* died on September 2. The comparatively great number of large tropical scenes that carry the same date has inspired one collector to suggest that all these pictures were not necessarily executed during Rousseau's last year but that, feeling his end approaching, the old man proceeded to sign the canvases stacked in his studio, naively providing each with the date of the current year, even though some may have been painted in 1909 or even earlier.

Edouard Vuillard is particularly well represented with a broadly executed view of a room with figures and a rare landscape in which trees and grazing animals dot a vast, empty hillside on which they are distributed so harmoniously while the composition is established so perfectly that the viewer feels drawn into the place without even noticing the amazing variety of spatial solutions proposed by the artist. There is also a precious interior, full of lovingly treated objects, that reveals the touching, bent figure of the painter's aged mother, around whom so many of his works were conceived. Another interior with a

golden chair is much more opulent, but what it loses in intimacy it gains in the daring plunging view in which the typically bourgeois setting and the two figures that occupy it are shown. Finally, in his flower piece, the mass of apparently carelessly gathered foliage and blossoms is set off by a lively wallpaper in an opposition and combination of patterns that is one of the artist's hallmarks. Félix Vallotton, like his friend Vuillard though in a very different way, chose an interior for a masterly arrangement of flat areas and precisely rendered details; a room crowded with objects is perceived through the door of an almost completely bare hall, a device that reveals a startling approach to a perfectly everyday subject.

Some of the painters represented in the Mellon gift are not often seen in American museums. This is true notably of Frédéric Bazille, whose tragically short life span severely curtailed his production. The corner of his Paris studio on the rue Visconti is an extremely interesting and at the same time intimate work, like a page from a personal diary, yet rich with compositional innovations. Among the seldom seen artists who will eventually take their rightful place is Roger de La Fresnaye; his two still lifes reveal the painter's very personal Cubism where large surfaces of strong colors surround objects whose forms have been reduced to their essential shapes. Another rarely seen artist and one who, like La Fresnaye, forged his own language of Cubism, is Jacques Villon; his imposing *The Three Orders* is one of the artist's major and typical works with its grid of color fields from which soaring forms emerge. Villon's horses at Chantilly likewise illustrates his very original integration of colors and planes, of abstraction and acute observation of reality. Like Degas's painting of horses, Villon's large composition represents a subject close to the heart of the donor; Paul Mellon's interest in breeding and racing has always been an essential part of his very active life.

There are works by still other artists in the Mellon gift, from Théodore Géricault, Eugène Delacroix, and Gustave Courbet to Edouard Manet, James Tissot, Gustave Caillebotte, and André Derain; from Henri de Toulouse-Lautrec, Kees van Dongen, and Maurice Utrillo to René Magritte, Albert Marquet, and Henri Matisse; their individual works are analyzed in this catalogue. Yet the group as a whole does not pretend to offer a complete survey of French art of practically the last one hundred years. What in fact it does is highlight many moments of those years so rich in great achievements. These works are now leaving the privacy of two discriminating and privileged art-lovers to become accessible to everyone for study and enjoyment.

JOHN REWALD

4

THE CATALOGUE

The catalogue is organized in two sections, Nineteenth Century and Twentieth Century; within each section artists are listed alphabetically. Measurements are given first in centimeters and, following in parentheses, in inches; height precedes width. Virginia Museum of Fine Arts accession numbers appear on the last line of the entry heading; the first two digits indicate the year the work was accessioned.

NINETEENTH CENTURY

JEAN-FREDERIC BAZILLE (1841–1870)

Born in Montpellier, Bazille moved to Paris in the early 1860s and studied under Charles Gleyre with Renoir, Monet, and Sisley. All four shared common artistic ideals and interests, and the evolution of early Impressionism was largely a product of their joint efforts. Bazille was killed in action at the battle of Beaune-la-Rolande during the Franco-Prussian War.

1 *The Artist's Studio, Rue Visconti, Paris,* 1866–67

Oil on canvas, 64.7 x 48.2 (25 1/2 x 19)
Not signed
Acc. no. 83.4

This is a view of the studio Bazille occupied from July 1, 1866, to December 30, 1867; he shared it with his less well-to-do friends Monet and Renoir. It was during this year and a half that Bazille and Monet undertook the project of painting large-scale plein-air figure compositions. Bazille's *Family Reunion* (Musée d'Orsay, Galerie du Jeu de Paume, Paris), executed in 1867 and shown at the Salon of 1868, is his most ambitious effort in this genre. It has been suggested that the picture on the easel in the Mellon painting may be the smaller first version of the *Family Reunion* (Musée du Petit Palais, Geneva), which the artist was working on during the winter of 1866–67.[1]

REFERENCES: Gaston Poulain, *Bazille et ses amis* (Paris, 1932), p. 214, no. 19. François Daulte, *Frédéric Bazille et son temps* (Geneva, 1952), no. 21. John Rewald, *The History of Impressionism*, 4th rev. ed. (New York, 1973), p. 184 (illus.). Linda Walters, "The West Wing: The Grand Tradition Continued," *Arts in Virginia* 23/1–2 (1982–83): 34 (illus.)

EXHIBITIONS: *Exposition Internationale de Montpellier: Rétrospective Bazille*, Montpellier, 1927, no. 15. *Frédéric Bazille*, Association des Etudiants Protestants, Paris, 1935, no. 8 (illus.). *Centenaire de Frédéric Bazille*, Musée Fabre, Montpellier, 1941, no. 19. *Bazille*, Galerie Wildenstein, Paris, 1950, no. 28 (illus.). *French Paintings from the Collections of Mr. and Mrs. Paul Mellon and Mrs. Mellon Bruce*, National Gallery of Art, Washington, D.C., March 17–May 1, 1966, no. 110 (illus.). *Frédéric Bazille and Early Impressionism*, Art Institute of Chicago, March 4–April 30, 1978, no. 23 (illus.).

COLLECTIONS: André Bazille, Montpellier. Wildenstein & Co., New York, until 1961.

[1] *Frédéric Bazille and Early Impressionism*, exhibition catalogue, Art Institute of Chicago, p. 64 (see "Exhibitions"). The same catalogue succeeds in identifying some of the other paintings visible on the studio walls, including works by Monet and Bazille.

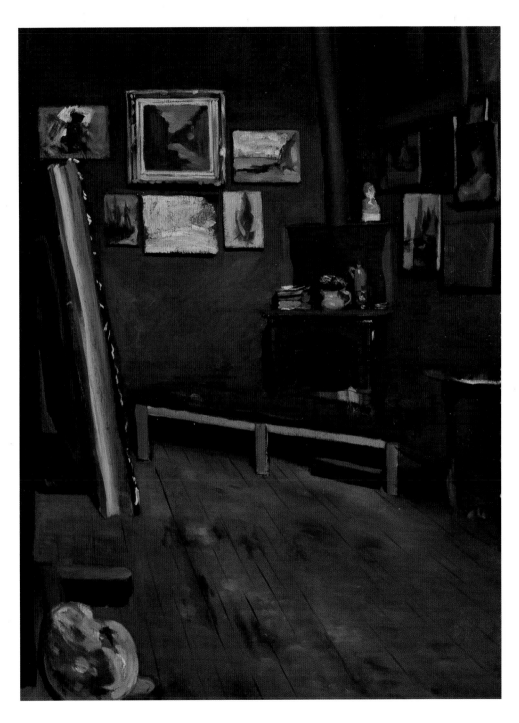

EUGENE BOUDIN (1824–1898)

Boudin's activity was largely confined to Normandy and Brittany, although he occasionally worked elsewhere in France, as well as in Holland and Belgium. In the 1890s he made two trips to Italy that resulted in an extensive series of Venetian views. His career began under the inspiration of the Barbizon artists and, especially, Corot. In turn, his example and direct influence on Monet made a significant contribution to the Impressionist movement.

2 *The Regatta*, ca. 1858

> Oil on panel, 17.5 x 26.3 (6⅞ x 10⅜)
> Signed, lower right: *Boudin*
> Acc. no. 83.7

Boudin, the son of a pilot, was born in Honfleur, the harbor of which is depicted here. His favorite subject, it recurs frequently in his work from 1850 on.

REFERENCES: Robert Schmit, *Eugène Boudin, 1824–1898*, vol. 1 (Paris, 1973), no. 193, p. 62 (illus., as *Le Port d'Honfleur*); *Premier Supplément* (Paris, 1984), no. 193, p. 133.

EXHIBITIONS: *French Landscapes*, Marlborough Fine Art, Ltd., London, Oct.–Dec. 1961, no. 5 (illus.).

COLLECTIONS: Galerie Durand-Ruel, Paris. Lord Radcliffe, London. Marlborough Fine Art, Ltd., London, until 1961.

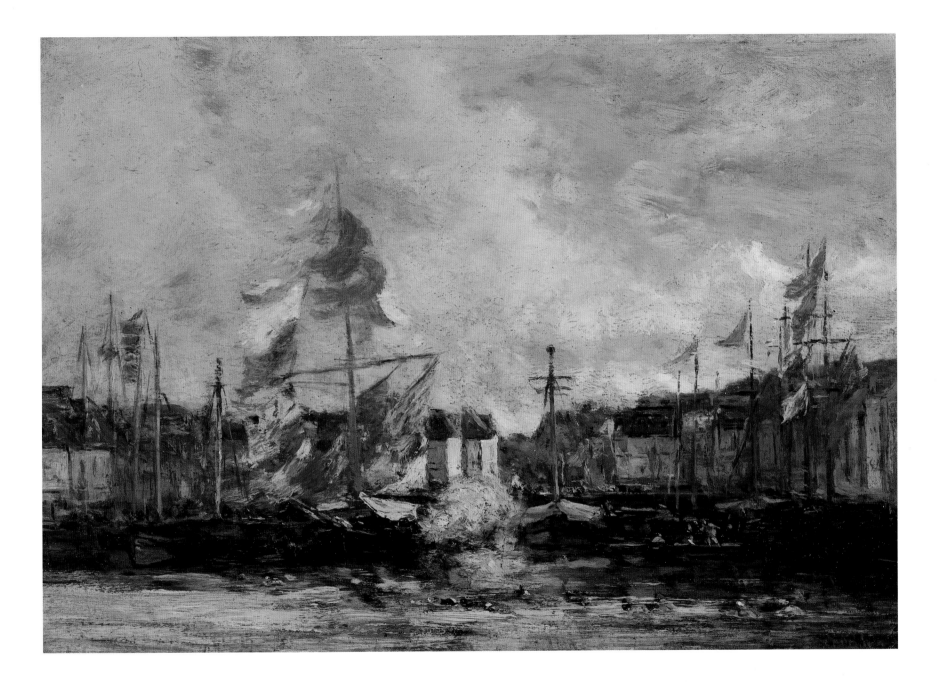

3 *Washerwoman, Trouville*, 1863

Oil on panel, 17.2 x 25.4 (6³/4 x 10)
Signed and dated, lower right: *E.B. 1863*
Acc. no. 83.6

Views of activities in the port and on the beaches of Trouville were common in Boudin's work from 1860 on.

REFERENCES: Robert Schmit, *Eugène Boudin, 1824–1898*, vol. 1 (Paris, 1973), no. 269, p. 86 (illus.); *Premier Supplément*, (Paris, 1984), no. k269, p. 134.

EXHIBITIONS: Gimpel Gallery, London, 1951. Marlborough Fine Art, Ltd., London, 1958. *French Paintings from the Collections of Mr. and Mrs. Paul Mellon and Mrs. Mellon Bruce*, National Gallery of Art, Washington, D.C., March 17–May 1, 1966, no. 19 (illus.).

COLLECTIONS: Hippolyte Fortin, Vimoutiers; sold Hôtel Drouot, Paris, May 9, 1901, no. 18. A. Tooth & Sons, London. Lady Sandwich, London; sold 1963. Oscar and Peter Johnson, Ltd., London, until 1963.

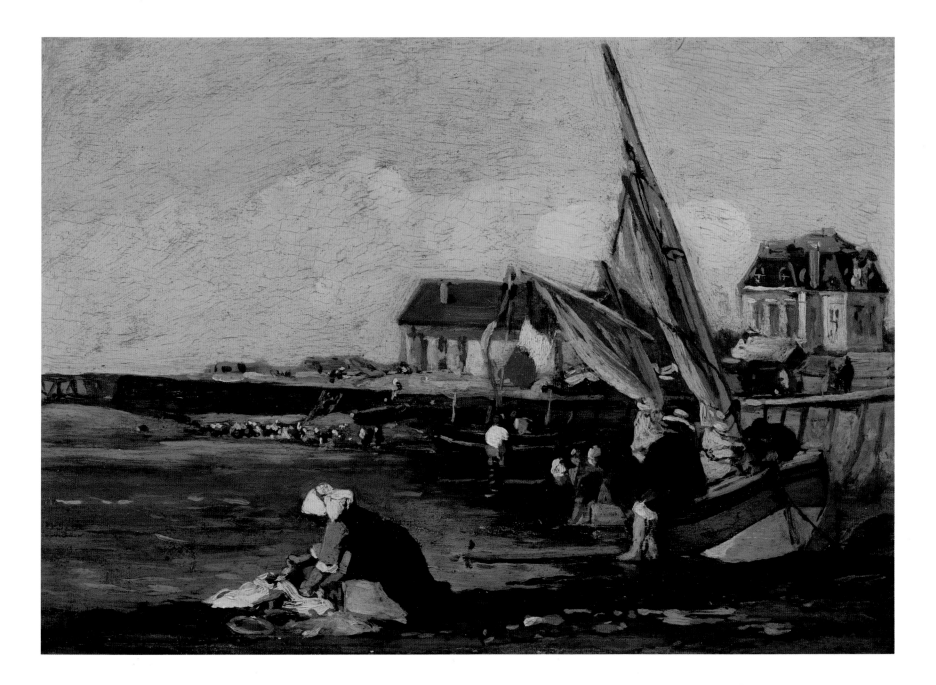

11

4 *The Beach at Trouville*, 1864

Oil on panel, 26.1 x 47 ($10^{1/4}$ x $18^{1/2}$)
Signed, lower right: *E. Boudin.*
Acc. no. 83.5

REFERENCES: G. Jean-Aubry, *Eugène Boudin, la vie et l'oeuvre d'après les lettres et les documents inédits* (Neuchâtel, 1968), p. 41 (illus.). Pierre Schneider, *The World of Manet 1832–1883* (New York, 1968), p. 55 (illus.). Robert Schmit, *Eugène Boudin, 1824–1898*, vol. 1 (Paris, 1973), no. 293, p. 98 (illus., as *Crinolines sur la Promenade le long de la Mer à Trouville*); *Premier Supplément* (Paris, 1984), no. 293, p. 135. *Horizon* (July/August 1982): 30 (illus.). Jean Selz, *Eugène Boudin* (Paris, 1982), p. 14 (illus.).

EXHIBITIONS: *French Paintings from the Collections of Mr. and Mrs. Paul Mellon and Mrs. Mellon Bruce*, National Gallery of Art, Washington, D.C., March 17–May 1, 1966, no. 17 (illus.).

COLLECTIONS: Cadart et Luquet, Paris. Godinot, Paris. Galerie Schmit, Paris. Hector Brame, Paris, until 1962.

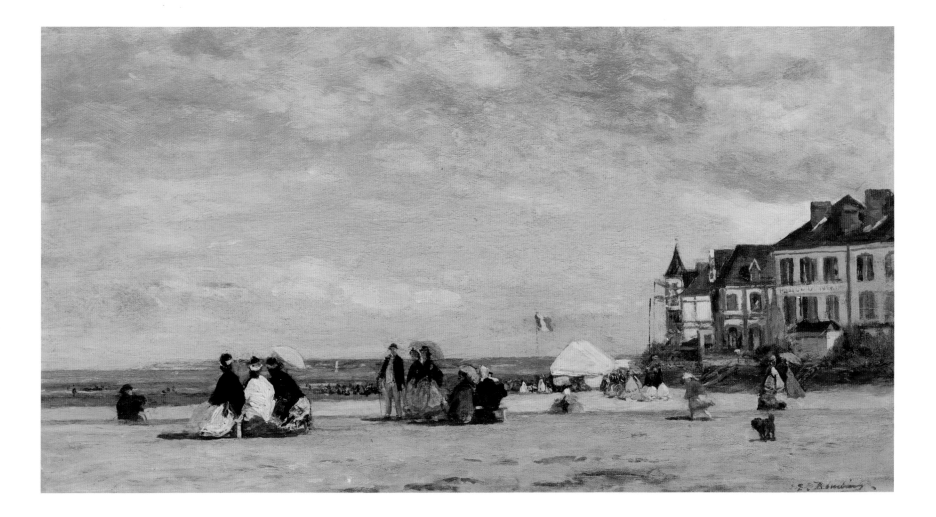

5 *"Pardon" in Finistère*, ca. 1865–70

Oil on panel, 41.9 x 31.7 (16½ x 12½)
Signed, lower right: *E. Boudin*
Acc. no. 83.10

In Brittany *pardons* are, basically, pilgrimages in quest of the remission of sin and its consequences. During the latter half of the decade of the '60s Boudin painted many scenes of Breton women gathering outside churches, presumably participating in *pardons*. The settings are usually in the Département of Finistère at the western extremity of Brittany, which Boudin visited for the first time in 1855. The artist's earliest representation of a *pardon* is *The Pardon of Sainte-Anne-La-Palaud* (Musée des Beaux-Arts, Le Havre) of 1858, an ambitious work (slightly over five feet wide) by which he was represented the following year in his initial appearance at the Paris Salon.

REFERENCES: G. Jean-Aubry, *Eugène Boudin, la vie et l'oeuvre d'après les lettres et les documents inédits* (Neuchâtel, 1968), p. 71 (color illus.). Robert Schmit, *Eugène Boudin, 1824–1898*, vol. 1 (Paris, 1973), no. 376, p. 138 (illus., as *Pardon en Bretagne*); *Premier Supplément* (Paris, 1984), no. 376, p. 137. P. Lemoisne, *Boudin roi des ciels* (Paris, 1981), p. 29 (illus.).

COLLECTIONS: Hippolyte Fortin, Vimoutiers. Dr. Boullard, Paris. Sold Palais Galliera, Paris, Dec. 8, 1966, no. 19 (illus.). Galerie Schmit, Paris, until 1967.

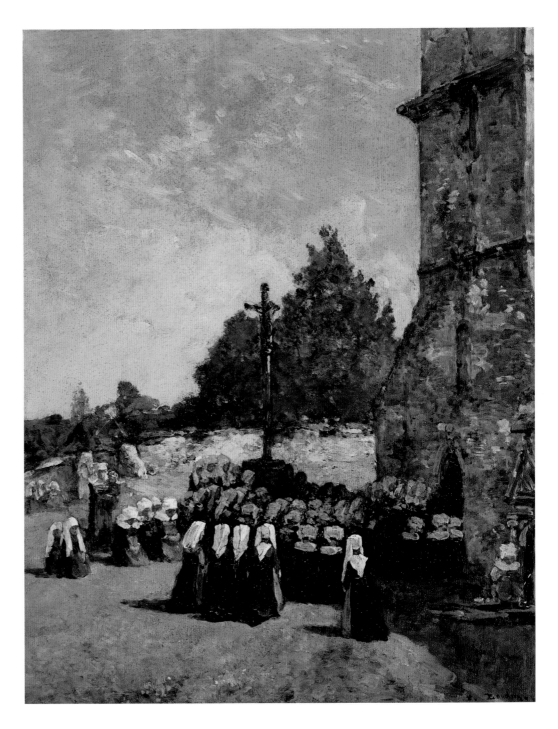

6 *Entrance to the Port of Le Havre*, 1888

Oil on canvas, 90 x 130.5 (35 ½ x 51 ⅜)
Signed, inscribed, and dated, lower right: *Le Havre E. Boudin 88*
Acc. no. 85.495

REFERENCES: Robert Schmit, *Eugène Boudin, 1824–1898*, vol. 2 (Paris, 1973), no. 2227, p. 350 (illus.); *Premier Supplément*, (Paris, 1984), no. 2227, p. 168.

EXHIBITIONS: Salon of 1889, Paris, no. 235. *La peinture française au XIXᵉ siècle*, Musée du Prince Paul, Belgrade, 1939, no. 1 (illus.).

COLLECTIONS: Galerie Durand-Ruel, Paris; purchased September 8, 1890. W. L. Andrews, New York. Wildenstein & Co., New York, until 1957.

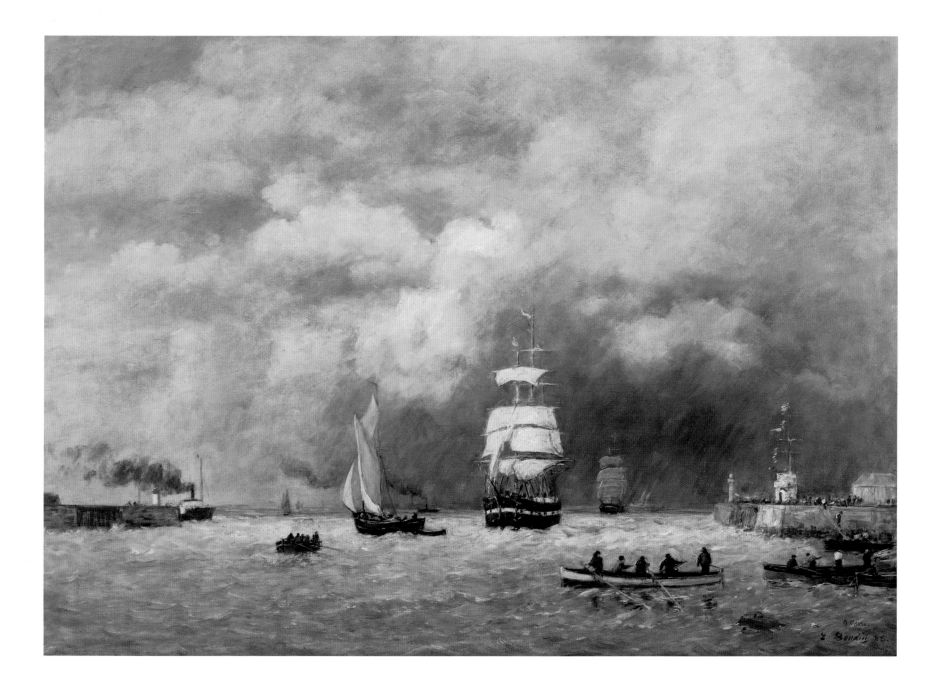

7 *French Fishing Fleet with Packet Boat*, 1889

Oil on canvas, 86.3 x 127 (34 x 50)
Signed and dated, lower left: *E. Boudin 1889*
Acc. no. 83.8

REFERENCES: Robert Schmit, *Eugène Boudin, 1824–1898*, vol. 2 (Paris, 1973), no. 2518, p. 448 (illus., as *Le Retour des Barques*); *Premier Supplément* (Paris, 1984), no. 2518, p. 172.

EXHIBITIONS: Société des Amis des Arts, Le Havre, 1890. *Exposition des oeuvres d'Eugène Boudin*, Ecole Nationale des Beaux-Arts, Paris, 1899, no. 216. *Pictures by Boudin, Cézanne, Degas, Manet, Monet, Morisot, Pissarro, Renoir, Sisley*, Grafton Galleries, London, January–February, 1905, no. 1.

COLLECTIONS: Galerie Durand-Ruel, Paris; purchased from the artist, June 26, 1889. Galerie Georges Petit, Paris; purchased from Galerie Durand-Ruel, Oct. 1, 1919. A. Bergaud, Paris; sold Galerie Georges Petit, Paris, March 1, 1920, no. 3. Chester Beatty. T. H. Bradford. John Baskett, Ltd., London, until 1970.

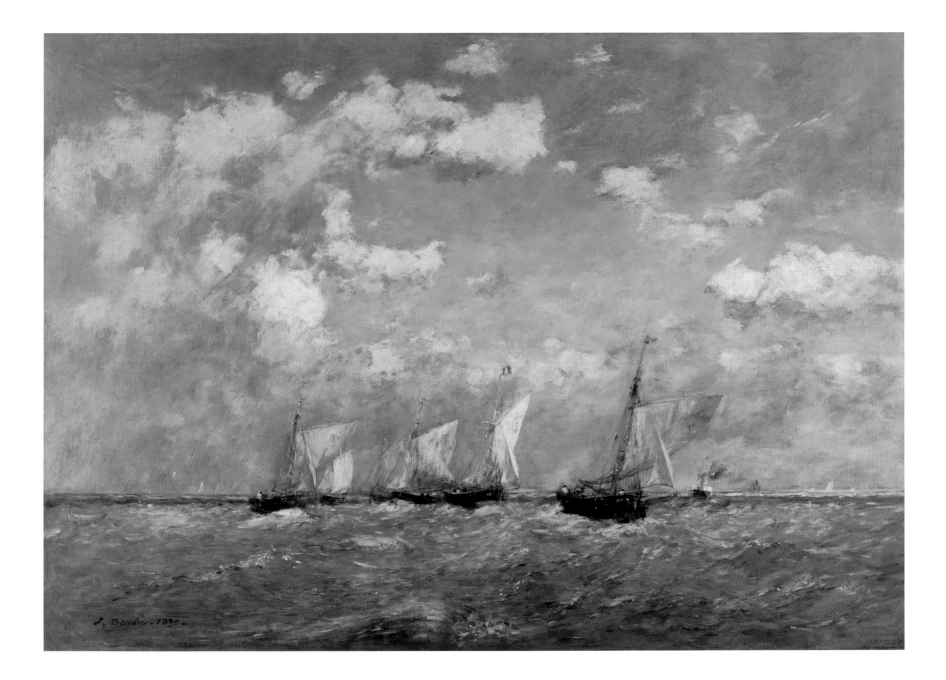

19

EUGENE BOUDIN

8 *The Beach at Trouville, Stormy Weather,* 1894

Oil on panel, 15.6 x 24.1 (6⅛ x 9½)
Inscribed and dated along bottom: *E. Boudin A mon ami Morlot 1894*
Acc. no. 83.9

REFERENCES: G. Jean-Aubry, *Eugène Boudin, la vie et l'oeuvre d'après les lettres et les documents inédits* (Neuchâtel, 1968), p. 117 (color. illus.). G. Jean-Aubry, *Eugène Boudin* (Greenwich, Conn., 1968), p. 117 (color illus.). Robert Schmit, *Eugène Boudin, 1824–1898*, vol. 3 (Paris, 1973), no. 3250, p. 247 (illus., as *Plage aux Environs de Trouville. Marée Basse*); *Premier Supplément* (Paris, 1984), no. 3250, p. 189.

COLLECTIONS: Alphonse Morlot, Paris. M^me Sauzet, Paris. Galerie Schmit, Paris, until 1966.

EXHIBITIONS: Salon of 1889, Paris, no. 235. *La peinture française au XIX^e siècle*, Musée du Prince Paul, Belgrade, 1939, no. 1 (illus.).

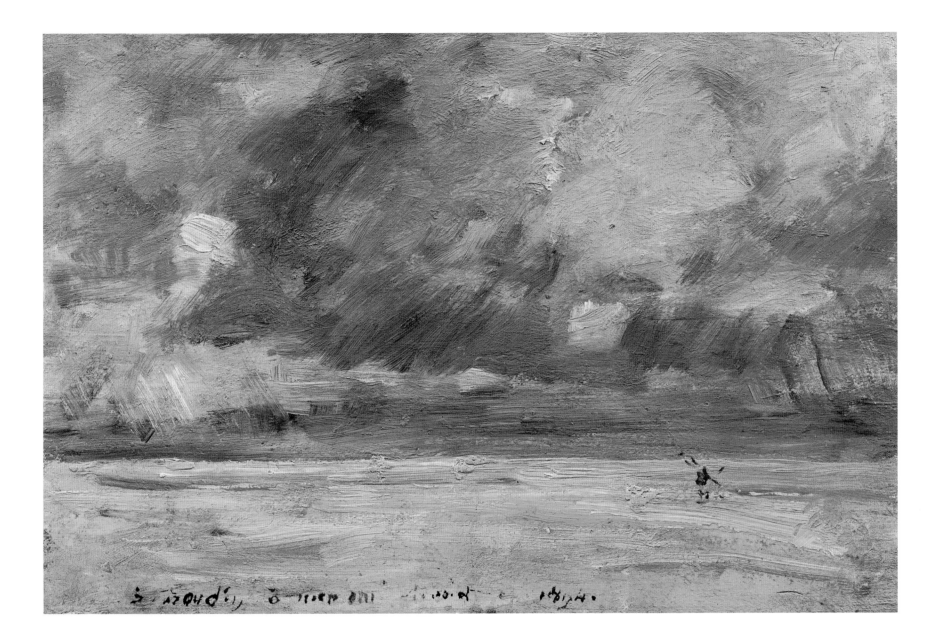

GUSTAVE CAILLEBOTTE (1848–1894)

The son of affluent parents, Caillebotte began academic training under Léon Bonnat in 1872 following military service in the Franco-Prussian War. By 1874 he had become associated with the Impressionists, and although he did not participate in their first exhibition that year he did in the second exhibition, 1876, submitting eight works. Until 1882 Caillebotte remained an active participant in and promoter of successive group exhibitions; he was also a major financial supporter through the purchase of paintings. However, he failed in his efforts to resolve the growing differences between the principal members of the group. By 1888 he had settled permanently at his country home in Petit Gennevilliers near Argenteuil; he continued to paint but with pure landscape and marine subjects predominating over the figure compositions he had favored earlier. His posthumous fame was due more to his bequest to the French nation of his extensive collection of works by his Impressionist friends than to his own work as a painter. In recent years, however, the merit of the latter has received increasing recognition.

9 *A Man Docking His Boat,* 1878

Oil on canvas, 73.6 x 92.7 (29 x 36½)
Signed and dated, lower right: *G. Caillebotte 1878*
Acc. no. 83.13

Caillebotte executed a series of boating scenes in 1878, the year of the death of his mother and the sale of the family property at Yerres, southeast of Paris. The river of that name provided the locale of these works. The boat depicted is a *périssoire*, a light, flat-bottomed skiff that is propelled by a twin-bladed kayak paddle.

REFERENCES: Marie Berhaut, *Caillebotte—sa vie et son oeuvre*, (Paris, 1978), no. 96 (illus.), p. 42 (color illus.).

COLLECTIONS: Alphonse Morlot, Paris. M^me Sauzet, Paris. Galerie Schmit, Paris, until 1966.

EXHIBITIONS: *La 4e Exposition de Peinture* (fourth Impressionist exhibition), 28, Avenue de l'Opéra, Paris, April 10–May 11, 1879, no. 13. *Rétrospective Gustave Caillebotte au Profit du Musée de Rennes,* Galerie Wildenstein, Paris, May 25–July 25, 1951, no. 22. *Gustave Caillebotte,* Wildenstein & Co., London, June 15–July 16, 1966, no. 12. *French Paintings from the Collection of Mr. and Mrs. Paul Mellon,* Virginia Museum of Fine Arts, April 4, 1967–June 5, 1968.

COLLECTIONS: Private collection, France. Wildenstein & Co., New York, until 1967.

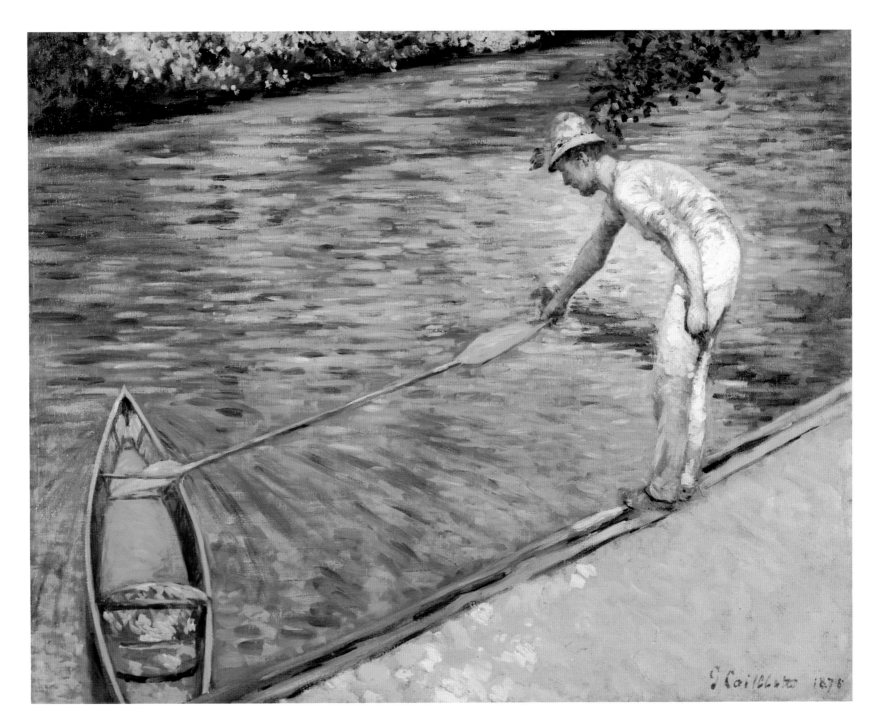

PAUL CEZANNE (1839–1906)

In the spring of 1861 Cézanne gave up the study of law and went to Paris to paint. His style of the 1860s is characterized by heavy impasto, somber color, and romantic flavor, but it gave way in the '70s to a manner closer to the Impressionists, especially that of Pissarro, whom he had known since his arrival in Paris. The latter part of his career was spent in and near the city of his birth, Aix-en-Provence, where after the death of his banker father he was quite well-off. From the early 1880s on he moved steadily away from Impressionism toward a structured idiom of great originality ("a harmony running parallel to nature," to quote the artist) that had immense implications for twentieth-century art.

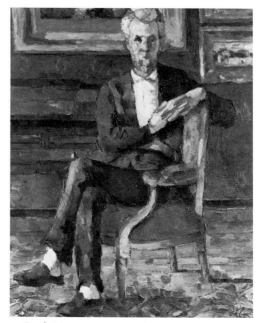

1. Paul Cézanne, *Victor Chocquet Seated*, ca. 1877, oil on canvas, 45.7 x 38.1 (18 x 15). Columbus Museum of Art, Museum Purchase, Howald Fund (50.24).

10 *Victor Chocquet,* ca. 1877

Oil on canvas, 35.2 x 27.3 (13⁷/₈ x 10³/₄)
Not signed
Acc. no. 83.14

Though he was a customs official of relatively modest means, Victor Chocquet (1821–1891) was an avid collector. Among his earliest acquisitions were works by Delacroix, and after 1875 his purchases included paintings by most of the major Impressionists, especially Cézanne (the sale following the death of Chocquet's widow in 1899 included more than thirty works by that artist). Of the known portraits of Chocquet by Cézanne the present one is most closely related to the seated version in the Columbus Museum of Art[2] (fig. 1). Indeed, it is so close in composition that John Rewald believes it to be either a study for the Columbus painting or else a version originally of the same format but cut down by the artist to its present size.[3] The absence of a tacking edge would tend to support the latter possibility without offering positive proof since tacking edges are commonly trimmed away when canvases are relined, as the Mellon painting has been.

Cézanne executed at least six painted and several drawn portraits of Chocquet beginning in the 1870s. At that time Chocquet was the only person to have commissioned portraits from Cézanne. More than just their mutual enthusiasm for the work of Delacroix drew them together. That a spiritual bond also existed is conveyed in a letter from Cézanne to Chocquet: "... I should have wished to possess the intellectual equilibrium that characterizes you and allows you to achieve with certainty the desired end. Your good letter ... bears witness to a great equilibrium of vital faculties. And so, as I am struck by this serenity, I discuss it with you. Fate has not endowed me with an equal stability, which is the only regret I have about the things on this earth."[4]

It is likely that Chocquet originally owned this portrait, but this cannot be proved since neither it nor any of the other likenesses by Cézanne were listed in the catalogue of his posthumous sale. What seems probable is that Ambroise Vollard purchased it at the Chocquet sale and that Degas later acquired it from Vollard.

REFERENCES: Galerie Georges Petit, Paris, *Vente Collection Edgar Degas*, Paris, March 26–27, 1918, no. 15, p. 21. A. Alexandre, "Sur Monsieur Degas," *Les Arts* (1918): no. 166. C. Marriott, *Modern Movements in Painting* (New York, n.d.), p. 201. P. Gasquet, "Aus dem Leben Cézannes," *Kunst und Künstler* 27/7 (April, 1929): 179. J. Gasquet, *Cézanne* (Berlin, 1930), illus. opp. p. 144. René Huyghe, "Cézanne et son oeuvre," *L'Amour de l'art*, 1936, p. 170, fig. 47. M. Raynal, *Cézanne* (Paris, 1936), pp. 99, 153 (illus., detail). L. Venturi, *Cézanne: son art—son oeuvre*, vol. 1 (Paris, 1936), p. 147, no. 375; vol. 2, pl. 103, fig. 375. Paul Cézanne, *Letters*, ed. John Rewald, trans. Marguerite Kay (London, 1941), illus. opp. p. 112, fig. 15. P. A. Lemoisne, *Degas et son Oeuvre*, vol. 1 (Paris, 1946), p. 178, illus. following p. 178, fig. D. John Rewald, *Paul Cézanne: A Biography* (New York, 1948), fig. 55. K. Badt, *The Art of Cézanne* (Berkeley and Los Angeles, 1965), p. 186. John Rewald, "Chocquet and Cézanne," *Gazette des Beaux-Arts*, 6th series, vol. 74 (July–August 1969): 53, fig. 12. M. Brion, *Cézanne* (Milan, 1972), p. 46 (color illus.). Ian Dunlop and Sandra Orient, *The Complete Paintings of Cézanne* (London, 1972), no. 502, p. 109 (illus.). Linda Walters, "The West Wing: A Grand Tradition Continued," *Arts in Virginia* 23 / 1–2 (1982–83): 35 (color illus.). Michael Wilson, *The Impressionists* (Oxford, 1983), p. 136, fig. 134. Barbara Ehrlich White, *Renoir, His Life, Art, and Letters* (New York, 1984), p. 57, p. 60 (illus.).

EXHIBITIONS: *Cézanne*, Musée de l'Orangerie, Paris, 1936. *Sammlung Rudolf Staechelin*, Kunstmuseum, Basel, May 13–June 17, 1956. *Fondation Rodolphe Staechelin: de Corot à Picasso*, Musée d'Art Moderne, Paris, April 10–June 28, 1964. *Impressionnistes*, Galerie Beyeler, Basel, Oct.–Nov. 18, 1967, no. 2 (illus.). *Degas*, Virginia Museum of Fine Arts, May 23–July 9, 1978.

COLLECTIONS: Victor Chocquet(?) (not included in catalogue of sale of Chocquet's collection following death of his widow, Paris, July 1–4, 1899). Ambroise Vollard, Paris. Edgar Degas, Paris; sold March 27, 1918, no. 15. Galerie Bernheim-Jeune, Paris-Lausanne; sold Dec. 31, 1918. Rudolf Staechelin, Basel. Rudolf Staechelin'sche Familienstiftung, Basel; (on extended loan to the Kunstmuseum, Basel, until 1967). Wildenstein & Co., New York, until 1968.

2 Venturi, *Cézanne*, no. 373 (see "References").

3 Rewald, "Chocquet and Cézanne," p. 53 (see "References").

4 Paul Cézanne, *Letters*, ed. John Rewald, trans. Marguerite Kay, 2d ed., rev. and enl. (New York, 1976), pp. 224–25.

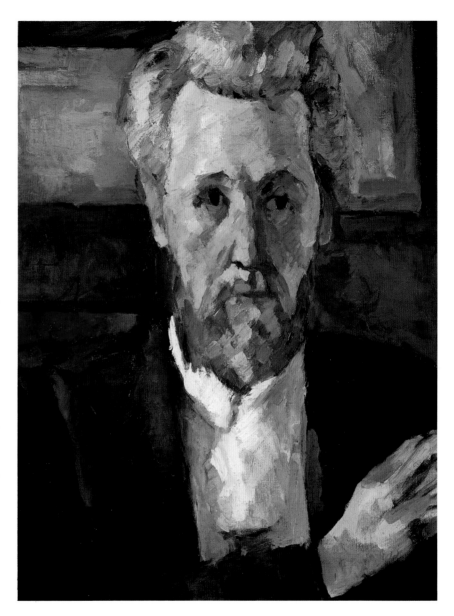

GUSTAVE COURBET (1819–1877)

The term Realism, designating the movement in French painting of which Courbet was the undisputed leader if not founder, connoted in the nineteenth century both an unacademic stance as well as a ready acceptance of nature in its unembellished rawness. In both senses Courbet performed a signal service toward mid-century and prepared the ground for the important movements of succeeding decades. He suffered six months imprisonment for his participation in the Paris Commune, and in 1873, a year after his release when it became clear that he was to be held responsible for the destruction of the Vendôme Column, he fled to Switzerland. He never returned to France.

11 *Gustave Chaudey,* 1868

Oil on canvas, 55.9 x 45.7 (22 x 18)
Signed and dated, lower left: *1868 Gustave Courbet*
Acc. no. 84.43

Another version of this painting, slightly larger and signed lower right but not dated, is known.[5]

Chaudey, a lawyer, Socialist, and longtime friend of Courbet, was executed by firing squad the night before the collapse of the Paris Commune, May 23, 1871, having been falsely charged with disloyalty by the Commune's attorney general, Raoul Rigault.

In a letter of December 22, 1868, Chaudey wrote to Courbet: "My portrait hanging in my office is stirring up endless controversy. The artists and connoisseurs approve; the ladies disapprove. They say you have tried to discredit me in the eyes of the fair sex. . . . It's very amusing."[6] It is not known whether Chaudey was referring to the other version or to the Mellon painting.[7]

REFERENCES: Charles Léger, *Courbet* (Paris, 1929), pp. 155–56. Charles Léger, *Courbet et son temps* (Paris, 1948), p. 125. Gerstle Mack, *Gustave Courbet* (New York, 1951), p. 225. Jack Lindsay, *Gustave Courbet, His Life and Art* (New York, Evanston, San Francisco, London, 1973), p. 234. *Bulletin des Amis de Gustave Courbet* 50 (1973): 9 (illus.). [Note: These references may refer to the second version of the painting; see footnote 5.]

EXHIBITIONS: *Gustave Courbet,* Kunsthaus, Zurich, 1935–36, no. 99. *Gustave Courbet,* The Mayor Gallery, London, June 1936, no. 8.

COLLECTIONS: Georges Chaudey, Paris. Sid Collection, Paris. Albert Loeb and Krugier Gallery, New York, until 1968.

[5] Robert Fernier, *La vie et l'oeuvre de Gustave Courbet,* vol. 2 (Lausanne and Paris, 1978), no. 657 (illus.). The Mellon Collection is incorrectly included in the provenance of that version, which according to Fernier was donated to the Musées Nationaux by M amd M^me Pierre Lévy.

[6] Mack, *Courbet,* p. 225 (see "References").

[7] The Mellon painting was accidentally damaged in November 1981. The damage consisted of a rip extending from below the left nostril and across the forehead to a point approximately two inches above the head, and several less extensive rips, mostly to the left of the first one. The damage was repaired by John Brealey.

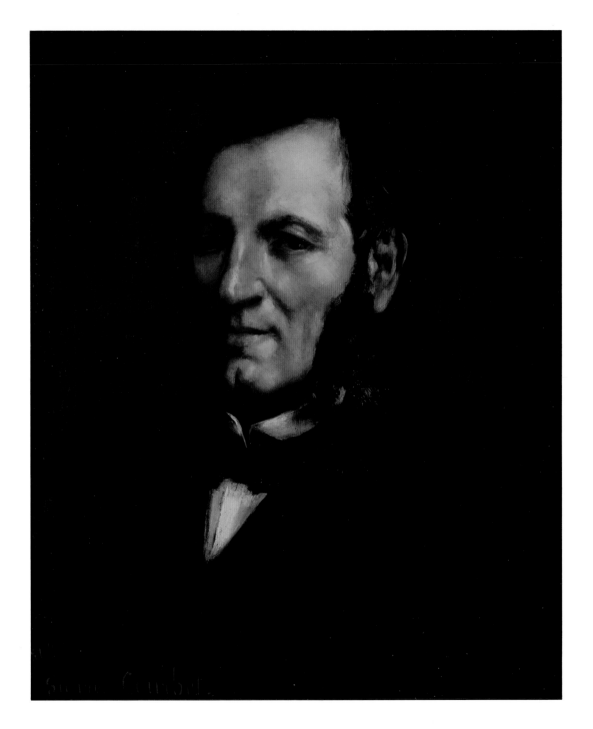

EDGAR DEGAS (1834–1917)

Although Degas was closely associated with the Impressionists in the 1870s and participated in their group shows, his art stands apart from theirs in many respects, particularly in his opposition to plein-air painting. Degas's early interest in history painting yielded in the 1870s to scenes from contemporary life; besides portraits, subjects such as ballet dancers, race horses, and women in intimate domestic settings preoccupied him during the rest of his career. These were also the subjects of the remarkable series of wax sculptures that, suffering from failing eyesight, he executed late in life.

12 *Julie Burtey,* ca. 1867

Oil on canvas, 73 x 59.7 (28³/₄ x 23¹/₂)
Estate stamp, lower right: *Degas*
Acc. no. 83.17

The sitter's identification as Julie Burtey, a Parisian dressmaker, was made by Theodore Reff in 1976 (see "References"). Previously, she was thought to be a Mᵐᵉ Julie Burtin. Reff catalogues a number of studies for the portrait in the artist's notebooks. There are also drawings for the entire composition (Fogg Art Museum) (fig. 2) and for the head (Sterling and Francine Clark Art Institute) (fig. 3).

The action of the sitter's left hand is somewhat ambiguous. In the Fogg drawing it is clear that the right arm is tightly secured under a shawl, two fingers of the right hand emerging at lap level. The left hand has been described as drawing the shawl over the right shoulder,[8] an action less evident in the painting, where the possibility that some very faintly discernible object (a book?) is standing upright under the left hand cannot be totally excluded.

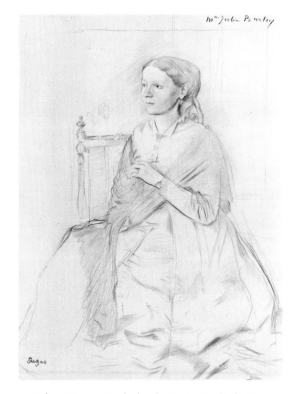

2. Edgar Degas, *Study for the Portrait of Julie Burtey,* hard and soft graphite on white paper with touches of white chalk, 36.1 x 27.2 (14⁷/₃₂ x 10²³/₃₂). Fogg Art Museum, Harvard University, Bequest of Meta and Paul J. Sachs.

REFERENCES: Galerie Georges Petit, Paris, 1ʳᵉ *Vente, Atelier Edgar Degas,* May 6–8, 1918, p. 47, no. 85 (illus., as "portrait de femme en robe noire"). Agnes Mongan and Paul Sachs, *Drawings in the Fogg Museum of Art,* vol. 1 (Cambridge, Mass., 1940), p. 357. P. A. Lemoisne, *Degas et son oeuvre,* vol. 2 (Paris, 1946), no. 108, pp. 54, 55 (illus.). Jean Boggs, *Portraits by Degas* (Berkeley, California, 1962), p. 111.

Theodore Reff, "The Chronology of Degas's Notebooks," *Burlington Magazine* 107 (Dec. 1965): 613 (footnote 88). Franco Russoli and Fiorella Minervino, *L'opera completa di Degas* (Milan, 1970), no. 155 (illus.). Theodore Reff, *The Notebooks of Edgar Degas* (Oxford, 1976), p. 6 (footnote 2), pp. 110, 111. Linda Walters, "The West Wing: A Grand Tradition Continued," *Arts in Virginia* 23 / 1–2 (1982–83): 32 (color illus.).

EXHIBITIONS: *Delacroix to Gauguin: Ten Portraits,* Virginia Museum of Fine Arts, May 4–Aug. 19, 1962. *French Paintings from the Collections of Mr. and Mrs. Paul Mellon and Mrs. Mellon Bruce,* National Gallery of Art, Washington, D.C., March 17–May 1, 1966, no. 51 (illus.).

COLLECTIONS: Edgar Degas, Paris; sold May 1918. Monteux collection. Private collection, New York. Jacques Lindon. Wildenstein & Co., New York, until 1961.

[8] Mongan and Sachs, *Drawings in the Fogg Museum,* p. 356 (see "References").

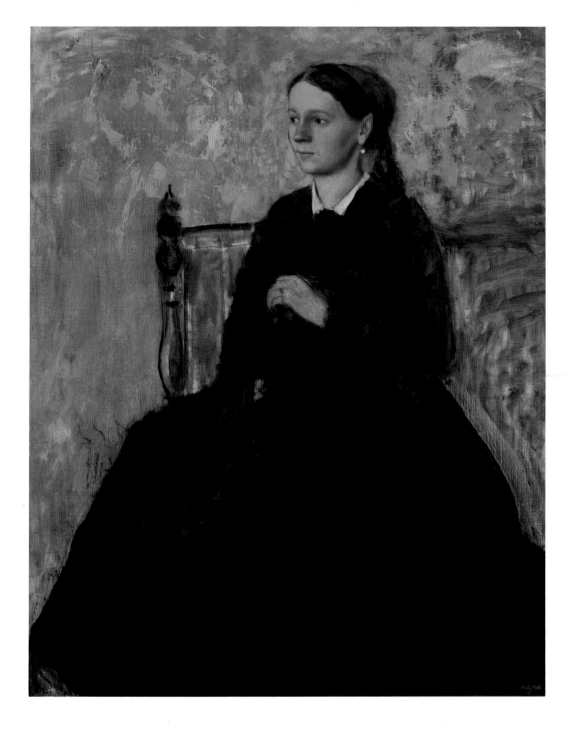

3. Edgar Degas, *Julie Burtey*, black and dark brown pencil, 30.8 x 21.6 (12 1/8 x 8 1/2). Sterling and Francine Clark Art Institute, Williamstown, Massachusetts.

13 *Alfred Niaudet,* ca. 1877

Oil on canvas, 46 x 32.1 (18⅛ x 12⅝)
Signed, upper right: *Degas*[9]
Acc. no. 83.16

Alfred Niaudet (1835–1883), a friend of Degas, was an engineer and the author of books on electrical subjects. His death is referred to in a letter from Degas to Henri Rouart.[10]

REFERENCES: P. A. Lemoisne, *Degas et son oeuvre*, vol. 2 (Paris, 1946), no. 439, pp. 240, 241 (illus.). Franco Russoli and Fiorella Minervino, *L'opera completa di Degas* (Milan, 1970), no. 433 (illus.).

EXHIBITIONS: *Exposition Degas*, Galerie Georges Petit, Paris, 1924, no. 61. *Degas. Portraitiste, Sculpteur*, Musée de l'Orangerie, Paris, 1931, no. 68. *Degas dans les Collections Françaises*, Galerie de la Gazette des Beaux-Arts, Paris, 1955, no. 75. *Edgar Degas*, Galerie Durand-Ruel, Paris, June 9–Oct. 1, 1960, no. 17. *Degas*, Virginia Museum of Fine Arts, May 23–July 9, 1978, no. 9.

COLLECTIONS: Niaudet family, Paris; sold Palais Galliera, Paris, March 30, 1968.

[9] According to Lemoisne, *Degas et son oeuvre*, vol. 2, p. 240, the signature was added later (see "References").

[10] Edgar Degas, *Letters*, ed. Marcel Guérin (Oxford, 1947), pp. 73–74, no. 54.

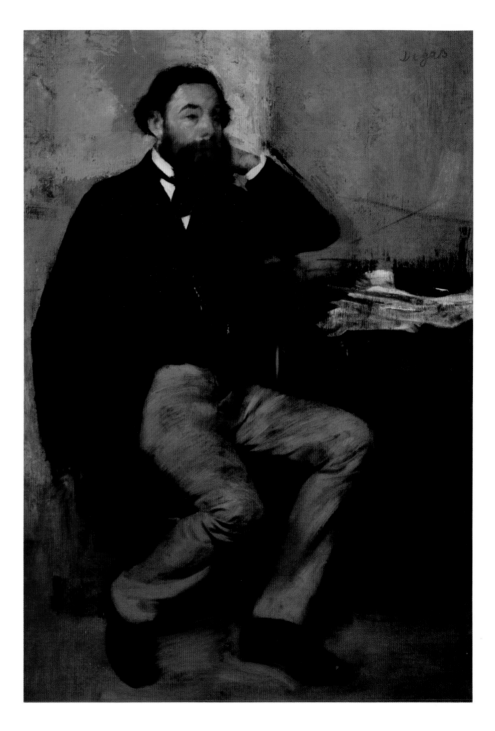

14 *Race Course: Before the Start*, 1878–80

Oil on canvas, 40 x 90 (15 3/4 x 35 3/8)
Signed, lower left: *Degas*
Acc. no. 85.496

Race Course: Before the Start is from a series of oil paintings and pastels—depicting similar subjects and using the same elongated format—that was executed over a period extending from the late 1870s to about 1890. The influence of photography on these works, even on their format, is undeniable. It is known that Degas was keenly interested in the instantaneous photographs of horses in motion published by Eadweard Muybridge; drawings based directly on Muybridge exist from the mid and late 1880s.[11] The artist's notebooks document his acquaintance with the work of Muybridge as early as 1878, around the time he began the series to which *Race Course: Before the Start* belongs.[12] The second horse from the right has been related to a charcoal drawing by Degas.[13]

REFERENCES: G. Geffroy, *L'Art et les Artistes* (April 1908), p. 15 (illus.). G. Grappe, *L'Art et le Beau*, 3rd year, I, p. 6 (illus.). P. A. Lemoisne, *Degas* (Paris, 1911?), p. 79 (illus.). L. Hourticq, *Art et Decoration* (1912), p. 97 (illus.). Henri Herz, *Degas* (Paris, 1920), p. 26. J. Meier-Graefe, *Degas* (London, 1923), pl. LIV. R. Huyghe, *L'Amour de l'Art* (1931), p. 272 (illus.). *Commemorative Catalogue of the Exhibition of French Art, 1200–1900*, Royal Academy of Arts, London, January–March 1932 (Oxford and London, 1933), no. 351. A. Alexandre, *L'Art et les Artistes* (February 1935): 171 (illus.). C. Mauclair, *Degas* (Paris, 1937), p. 85 (illus.). P. A. Lemoisne, *Degas et son oeuvre*, vol. 2 (Paris, 1946), no. 502, pp. 278, 279 (illus.). William M. Kane, "Gauguin's Cheval Blanc," *Burlington Magazine* (July 1966): 361, pl. 31. J. Lassaigne and F. Minervino, *Tout l'oeuvre peint de Degas* (Paris, 1974), no. 687 (illus.). Richard R. Brettell and Suzanne Folds McCullagh, *Degas in The Art Institute of Chicago* (Chicago and New York, 1984), p. 126.

EXHIBITIONS: Grafton Galleries, London, 1908, no. 50. *French Art*, Royal Academy, London, 1932, no. 453. *Fifty-ninth Exhibition*, Liverpool, 1933. *Degas*, Musée de l'Orangerie, Paris, 1937, no. 28 (illus.). *Pictures Collected by Yale Alumni*, Yale University Art Gallery, May 8–June 18, 1956, no. 92 (illus.). *Sport and The Horse*, Virginia Museum of Fine Arts, April 1–May 15, 1960, no. 60 (illus.). *French Paintings from the Collections of Mr. and Mrs. Paul Mellon and Mrs. Mellon Bruce*, National Gallery of Art, Washington, D.C., March 17–May 1, 1966, no. 54 (illus.). *Degas'*

Racing World, Wildenstein & Co., New York, March 21–April 27, 1968, no. 7 (illus.). *Celebration*, Museum of Art, Carnegie Institute, Pittsburgh, Oct. 25, 1974–Jan. 5, 1975. *Degas*, Virginia Museum of Fine Arts, May 23–July 9, 1978, no. 11.
COLLECTIONS: Durand-Ruel, Paris. Mrs. A. Chester Beatty, London. Paul Rosenberg & Co., New York, until 1955.

[11] Van Deren Coke, *The Painter and the Photograph, from Delacroix to Warhol* (Albuquerque, 1964), figs. 349–55.
[12] Theodore Reff, *Degas, The Artist's Mind* (New York, 1976), pp. 293–94, footnote 61.
[13] Brettell and McCullagh, *Degas in Chicago*, p. 126 (see "References").

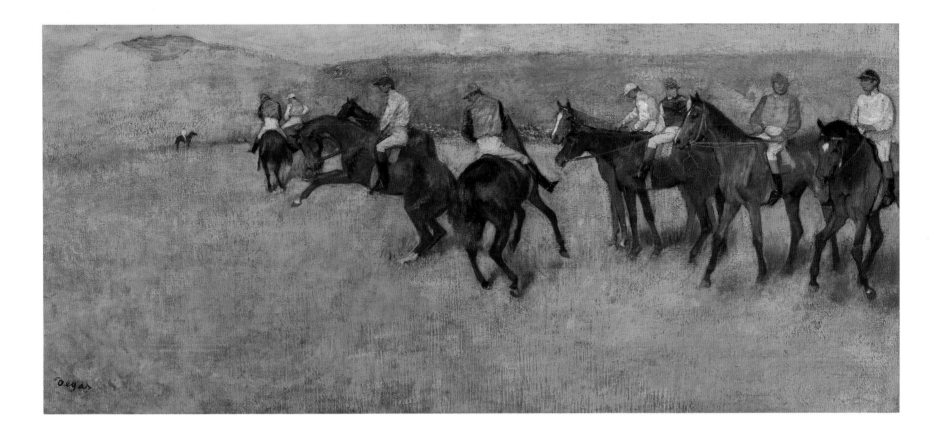

33

EUGENE DELACROIX (1798–1863)

Delacroix was the major representative of the Romantic movement in French painting. However, his art had complex roots: the near-contemporary work of Bonington and Constable, and above all the paintings of such old masters as Veronese and Rubens. His career was one of unswerving dedication to his artistic ideals; the technical means he developed to attain them, especially his brushwork and color, were a source of inspiration to the Impressionists when they were taking their first steps around the time of Delacroix's death. Except for brief trips abroad—including England in 1825 and North Africa in 1832—Delacroix's activity was confined mostly to Paris.

15 *Study of a Brown-Black Horse Tethered to a Wall,* ca. 1823

Oil on canvas, 52.1 x 72.1 (20½ x 28⅜)
Red wax estate monogram, back of stretcher: *E.D.*
Acc. no. 83.18

Delacroix's work of the early 1820s contains numerous studies of horses.[14] A great many of these appeared in the catalogue of his posthumous sale, but not all can be located today.

REFERENCES: Pierre Georgel and Luigina Rossi Bortolatto, *Tout l'oeuvre peint de Delacroix* (Paris, 1972) (included among nos. 829–41 but unspecified). Lee Johnson, *The Paintings of Eugène Delacroix,* vol. 1 (Oxford, 1981), no. 47, p. 31; vol. 2, pl. 40. Linda Walters, "The West Wing: A Grand Tradition Continued," *Arts in Virginia* 23 / 1–2 (1982–83): 35 (color illus.).

EXHIBITIONS: *Chevaux et cavaliers,* Galerie Charpentier, Paris, 1948, no. 48. *Delacroix,* Wildenstein & Co., London, 1952, no. 5. *French Paintings from the Collection of Mr. and Mrs. Paul Mellon,* Virginia Museum of Fine Arts, April 4, 1967–June 5, 1968.

COLLECTIONS: The artist; atelier sale, Feb. 1864, part of lot 210. Léon Suzor, Paris, until 1965. Claude Aubry. Drs. Fritz and Peter Nathan, Zurich, until 1965.

[14] Johnson, *Paintings of Delacroix,* vol. 1, pp. 29ff. (see "References").

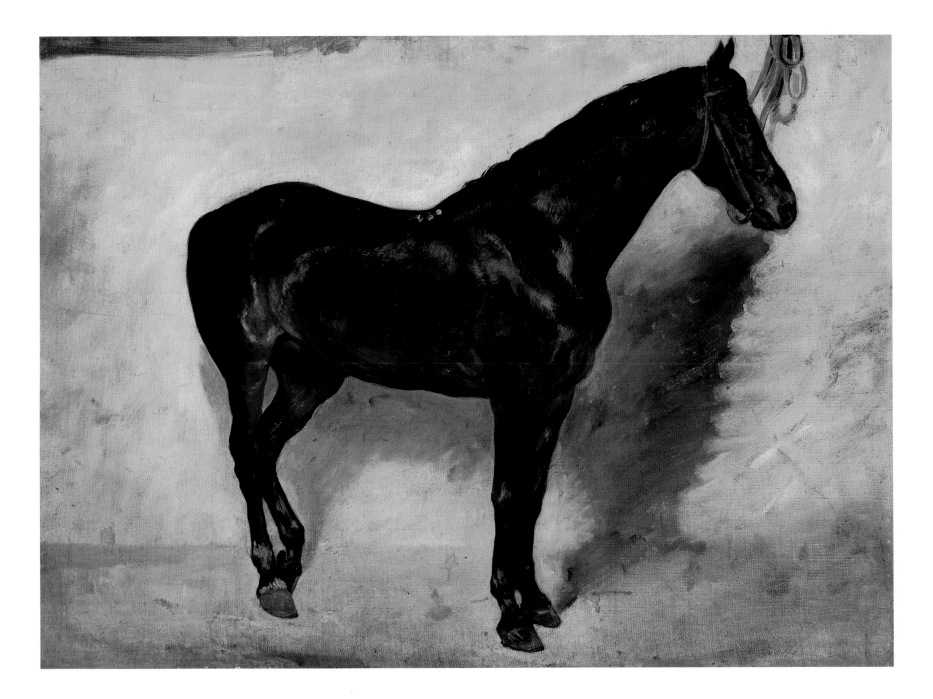

HENRI FANTIN-LATOUR (1836–1904)

Fantin-Latour considered himself a realist. From early on Courbet was his principal influence, and as a result a constant characteristic of his style was the highly exacting rendering of light and texture in the interest of surface verisimilitude. In his approach to subject, however, he often shows a bias toward lyrical or romantic expression. This can be seen not only in the flower paintings, which make up the most familiar portion of his oeuvre, but also in his portraits, group and single, and especially in those subjects of Wagnerian inspiration. Fantin-Latour first showed at the Salon of 1861; the remainder of his career was marked by steady, even success. He was acquainted with Manet and other prominent Impressionists, although he did not sympathize with their aims and never exhibited with them.

16 *Bouquet of Zinnias*

Oil on canvas, 29.2 x 39.1 (11 1/2 x 15 3/8)
Signed, upper left: *Fantin*
Acc. no. 83.22

Most of Fantin-Latour's flower painting was done at his wife's small property in Normandy where the couple usually spent their summers. Of the nine or so depictions of zinnias ranging over a fourteen-year period (1881–95), this version cannot be identified with certainty in his widow's *Catalogue de l'Oeuvre Complet de Fantin-Latour*.[15]

COLLECTIONS: K. W. Woolcombe-Boyce, Red Hill (Surrey), England. Wildenstein & Co., New York, until 1957.

[15] Paris, 1911 (reprinted 1969).

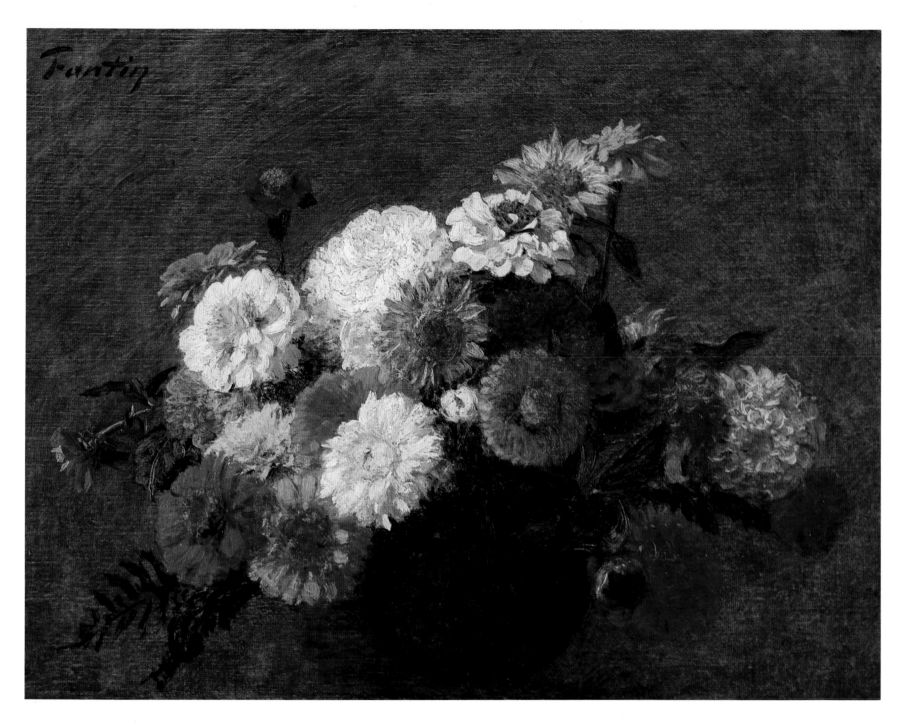

37

PAUL GAUGUIN (1848–1903)

Born in Paris, Gauguin spent part of his childhood in Peru. He was at sea in the Merchant Marine for six years, 1865–71, and then became a stockbroker. Until 1883 he practiced as a Sunday painter, and he had a keen interest in the Impressionists, with whom he exhibited in the early 1880s. His mature Synthetist style, which evolved in Pont-Aven (Brittany) and later in the South Seas, became one of the major rallying points for avant-garde artists of the turn of the century.

17 *Still Life with Oysters,* 1876

Oil on canvas, 53.3 x 93.2 (21 x 36¾)
Signed and dated, lower left: *P. Gauguin 1876*
Acc. no. 83.23

From the year 1876 only six paintings by the artist are known: four still lifes, a marine view, and a landscape with roebuck. The Mellon still life betrays the strong imprint of Manet's style.

REFERENCES: Georges Wildenstein, *Gauguin,* vol. 1 (Paris, 1964), no. 21 (illus.). Dennis Farr, "French Paintings from the Collections of Mrs. Mellon Bruce and Mr. and Mrs. Paul Mellon," *Antiques* 89/4 (April 1966): 561, fig. 10. Elda Fezzi, *Tout Gauguin* (Paris, 1982), no. 18 (illus.).

EXHIBITIONS: *Gauguin,* Galerie Charpentier, Paris, 1960, no. 3 bis. *Gauguin,* Haus der Kunst, Munich, 1960, no. 3. *French Paintings from the Collections of Mr. and Mrs. Paul Mellon and Mrs. Mellon Bruce,* National Gallery of Art, Washington, D.C., March 17–May 1, 1966, no. 122 (illus.).

COLLECTIONS: Michel Thibout, Paris; sold Palais Galliera, Paris, March 29, 1962, no. 69. Galerie Schmit, Paris, until 1964.

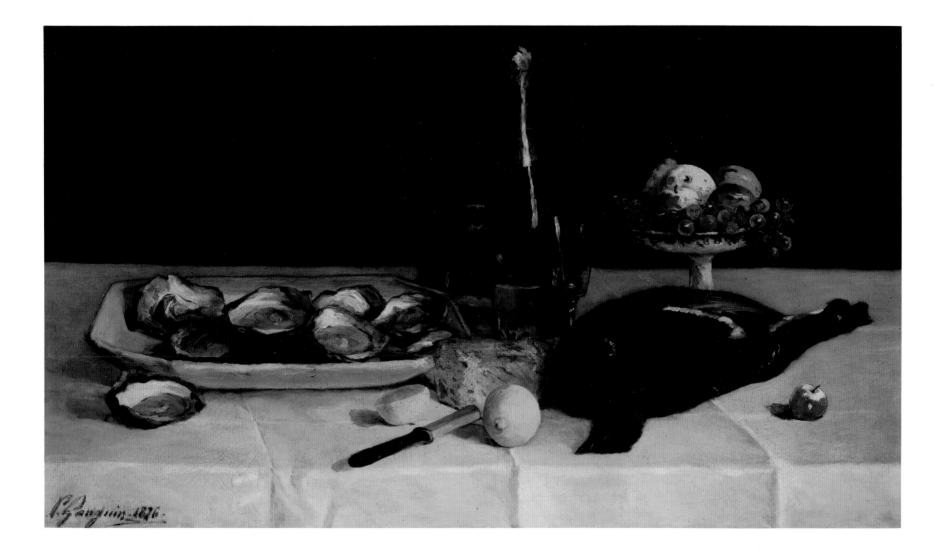

THEODORE GERICAULT (1791–1824)

Géricault was born in Rouen but lived in Paris from an early age. He studied with Carle Vernet and later was a fellow student of Delacroix in the studio of Pierre Guérin. With strong anti-academic bias, he developed a style of prodigious vitality and vivid expression, concentrating on subjects of everyday rural and urban life; scenes with horses particularly interested him. His most ambitious work, The Raft of the Medusa *(Musée du Louvre), dealt with an event from contemporary history. Although he exhibited relatively little and even though his career was short, he had great influence on the artists of his day. If any artist can be said to be the founder of the Romantic movement in French painting, it is Géricault.*

18 *Mounted Jockey (Jockey Montant un Cheval de Course)*, 1820–22

Oil on canvas, 36.8 x 46.4 (14½ x 18¼)
Not signed
Acc. no. 85.497

During Géricault's English sojourn of 1820–21 he produced a number of paintings of mounted jockeys. A lithograph of 1823 is related to the Mellon painting.[16]

REFERENCES: Walter Friedlaender, *David to Delacroix* (Cambridge, Massachusetts, 1952), p. 102, fig. 62. Catalogue of the Géricault exhibition, Kunstmuseum, Winterthur, Aug. 30–Nov. 8, 1953; mentioned under no. 97. Charles Clément, *Géricault* (1879; reprint, Paris, 1973), introduction and notes by Lorenz Eitner, note 138, p. 456. Jacques Thuillier and Philippe Grunchec, *L'Opera Completa di Géricault* (Milan, 1978), mentioned under no. 199.

EXHIBITIONS: *Degas' Racing World*, Wildenstein & Co., New York, March 21–April 27, 1968, no. 73 (illus.).

COLLECTIONS: William A. Coolidge, Topsfield, Massachusetts. M. Knoedler & Co., New York, until 1960.

[16] Thuillier and Grunchec, *L'Opera Completa di Géricault*, no. INC. 72 (see "References"). In the same volume, a painting is reproduced under no. 199 that appears to be identical to the Mellon painting. Max von Goldschmidt-Rothschild is cited as a former owner, and the authors express uncertainty as to whether it is identical to the Mellon version. Uncertainty also exists over the present location of the version included in Clément, *Géricault* (1879), no. 438, although Lorenz Eitner, in his notes to the reprint edition (see "References"), p. 456, suggests that it formed part of the collection of the late Col. Hans Buehler of Winterthur, Switzerland. That version is reproduced as no. 199A in Thuillier and Grunchec, *L'Opera Completa di Géricault.*

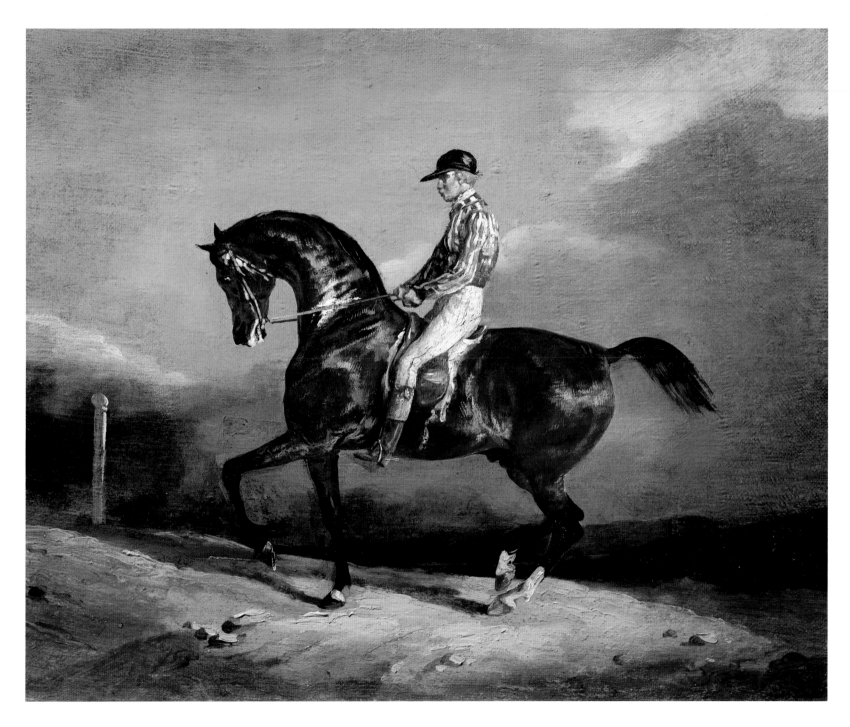

VINCENT VAN GOGH (1853–1890)

Van Gogh's artistic activity covers a mere ten years, but his production, especially during the last four, was enormous. The first six, 1880–86, were spent in Holland and Belgium, where in drawings and paintings of somber hue and subdued lighting he concentrated on peasants, mine-workers, tools, simple domestic objects, and occasional landscapes. The Bathing Float, Paris *(catalogue no. 19) is an example of the style he developed under Impressionist influence during his subsequent stay in Paris, and* Wheat Field Behind Saint Paul's Hospital, Saint Remy *(catalogue no. 20) illustrates the direction he was taking during the last months of his life.*

19 *The Bathing Float, Paris,* 1887

Oil on canvas, 19 x 27 (7½ x 10⅝)
Not signed
Acc. no. 83.25

Van Gogh spent two years in Paris, March 1886–February 1888. Much of the summer of 1887 was devoted to painting in the northwestern suburb of Asnières, where his subjects included landscapes, bridges, factories, restaurants, and, as here, a bathing float on the Seine.

REFERENCES: J. B. de La Faille, *L'oeuvre de Vincent van Gogh*, vol. 1 (Paris, 1928), no. 311; vol. 2, pl. LXXXV. J. B. de la Faille, *Vincent van Gogh* (New York and Paris, 1939), p. 276, no. 378 (illus.). Robert Goldwater, "The Glory that was France," *Art News* 65/1 (March 1966): 41 (illus.). Dennis Farr, "French Paintings from the Collections of Mrs. Mellon Bruce and Mr. and Mrs. Paul Mellon," *Antiques* 89/4 (April 1966): 563, fig. 15. J. B. de La Faille, *The Works of Vincent van Gogh* (Amsterdam, 1970), pp. 152, 153, 623, no. F 311 (illus., as *Bathing Place on the Seine at Asnières*). Jacques Lassaigne, *Vincent van Gogh* (Milan, 1972), p. 33 (color illus.). Jan Hulsker, *The Complete Van Gogh* (New York, 1984), pp. 292, 298, no. 1325 (illus.).

EXHIBITIONS: *Internationale Kunstausstellung des Sonderbundes westdeutscher Kunstfreunde und Künstler zu Köln*, Cologne, May 25–Sept. 30, 1912, no. 21. *Vincent van Gogh*, Paul Cassirer Gallery, Berlin, May–June 1914, no. 29. *Vincent van Gogh*, Paul Cassirer Gallery, Berlin, Jan. 15–March 1, 1928, no. 24. *Vincent van Gogh*, M. Goldschmidt Gallery, Frankfurt am Main, March 15–April 15, 1928, no. 14. *Hollandsche en Fransche schilderkunst der XIX en XX eeuw*, E. J. van Wisselingh & Co., Amsterdam, July–August, 1933, no. 48. *Peinture française du XIXᵉ siècle*, E. J. van Wisselingh & Co., Amsterdam, July 15–Aug. 17, 1935, no. 18. *Pictures Collected by Yale Alumni*, Yale University Art Gallery, New Haven, May 8–June 18, 1956, no. 100. *French Paintings from the Collections of Mr. and Mrs. Paul Mellon and Mrs. Mellon Bruce*, National Gallery of Art, Washington, D. C., March 17–May 1, 1966, no. 130 (illus.).

COLLECTIONS: Mrs. Tilla Durieux-Cassirer, Berlin. Mrs. Paret (née Cassirer), Berlin. Alfred Tietz, Cologne. Mrs. Aline Barnsdall, Beverly Hills, California. M. Knoedler & Co., New York. Mr. and Mrs. Edward Patterson, Glen Head, Long Island. Hector Brame, Paris, until 1964.

43

20 *Wheat Field Behind Saint Paul's Hospital, Saint Remy*, November–December 1889

Oil on canvas, 24.1 x 33.7 (9½ x 13¼)
Not signed
Acc. no. 83.26

This is a view from the artist's hospital room. It is a replica of a larger work in the Ny Carlsberg Glyptotek, Copenhagen, that was executed in June 1889.[17]

REFERENCES: J. B. de la Faille, vol. 1, *L'Oeuvre de Vincent van Gogh* (Paris, 1928), no. 722; vol. 2, pl. CCIV. W. Scherjon and W. Jos. De Gruyter, *Vincent van Gogh's Great Period. Arles, St. Remy and Auvers-sur-Oise* (Amsterdam, 1937), p. 345, no. 161 (under heading, "Replicas on a Small Scale Painted for van Gogh's Mother and Sister"). J. B. de la Faille, *Vincent van Gogh* (New York and Paris, 1939), no. 729 (illus.). J. B. de la Faille, *The Works of Vincent van Gogh* (Amsterdam, 1970), no. F 722 (illus. as *The Meadow Behind St. Paul's Hospital*). Jan Hulsker, *The Complete Van Gogh* (New York, 1984), p. 430, no. 1872 (illus.).

EXHIBITIONS: *Internationale Kunstausstellung des Sonderbundes westdeutscher Kunstfreunde und Künstler zu Köln*, Cologne, May 25–Sept. 30, 1912, no. 32. *Schilderijen door Vincent van Gogh, J. B. Jongkind, Floris Verster*, Huinck and Scherjon, Amsterdam, May 14–June 18, 1932, no. 20. *Verzameling H. P. Bremmer*, Gemeentemuseum, The Hague, March 9–April 23, 1950, no. 37. *Maîtres français du XIXᵉ et XXᵉ siècle*, E. J. van Wisselingh & Co., Amsterdam, June–Aug. 1958, no. 14. *Vincent van Gogh*, Musée Jacquemart-André, Paris, Feb.–March 1960, no. 56.

COLLECTIONS: Wilhelmina van Gogh, Dieren. C. M. van Gogh Art Gallery, Amsterdam. Paul Cassirer, Berlin. H. P. Bremmer, The Hague. Heirs of H. P. Bremmer. Paul Rosenberg & Co., New York, until 1966.

[17] De la Faille, *The Works of Vincent van Gogh*, 1970, pp. 246, 247, 635, no. F 611 (illus.), and for a related drawing, pp. 533, 667, no. F 1547 (illus.) (see "References").

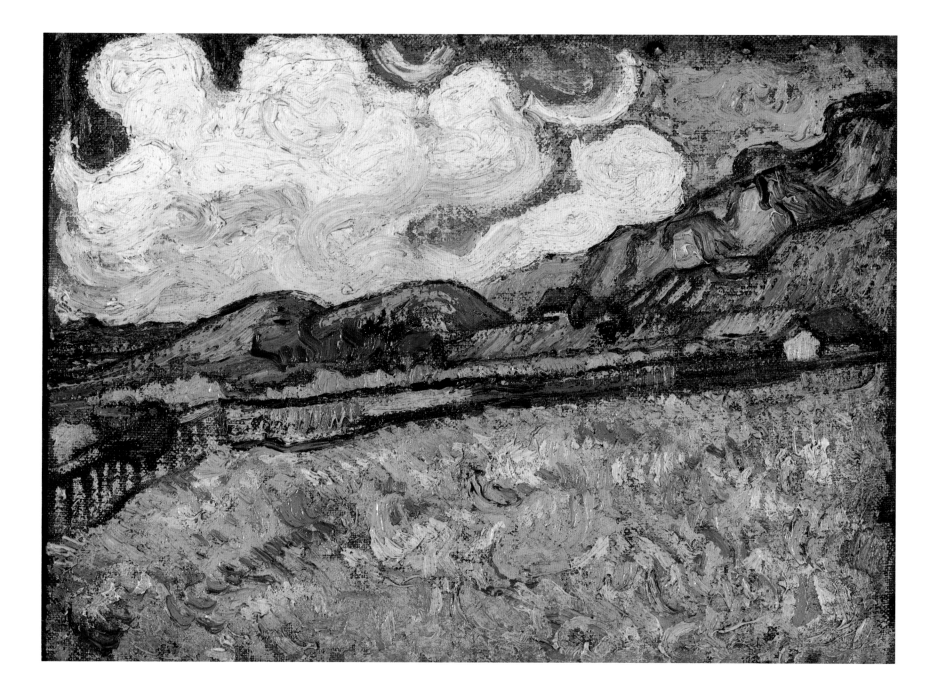

45

HENRI-JOSEPH HARPIGNIES (1819–1916)

Harpignies turned to painting at the age of twenty-seven, after having worked as a traveling salesman. 1853 was the year of his debut at the Paris Salon. He was almost exclusively a landscape painter (Anatole France later dubbed him the "Michelangelo of Trees"), and his early work was much influenced by Corot. However, from his middle years on he frequently abandoned the nearly monochromatic tonality of Corot for richer and more varied color. Some of his most successful work was done in watercolor.

21 *The Colas Road,* 1885

Oil on canvas, 50.2 x 80 (19³/₄ x 31¹/₂)
Signed and dated, lower left: *H J Harpignies 85*
Acc. no. 83.27

Harpignies' financial situation was greatly eased in 1883 when he signed a contract with the art dealers Arnold and Tripp, who thereafter managed the sale of his works. They commissioned large and important paintings such as his *Moonrise* of 1885 (Metropolitan Museum of Art, New York), a work of pronounced romantic mood explicitly based on lines by Victor Hugo. The Mellon painting, executed in the same year and depicting a locale not yet identified, shows a more direct and fresh interpretation of nature.

COLLECTIONS: Le Cercle de l'Union (private club), Paris. Hector Brame, Paris, until 1967.

JOHAN BARTHOLD JONGKIND (1819–1891)

Dutch by birth, Jongkind studied at the Academy of Drawing in The Hague before going to Paris in 1846. During the remainder of his life he was active mostly in France. In 1862 he met Boudin, who exercised considerable influence on his landscape style, a style that, in turn, was not without influence on Monet and other Impressionists. The latter part of his life was spent in the Dauphiné near Grenoble, where he died insane.

22 *The Seine at Bas Meudon*, 1865

Oil on canvas, 33 x 47 (13 x 18½)
Signed and dated, lower right: *Jongkind 1865*
Acc. no. 83.28

Two other versions of this painting, an oil and a watercolor, exist from 1865.[18]

REFERENCES: William Gaunt, *Impressionism, A Visual History* (New York and Washington, D. C., 1970), p. 68, pl. 7. Victorine Hefting, *Jongkind, sa vie, son oeuvre, son époque* (Paris, 1975), no. 333 (illus.).
EXHIBITIONS: *Dutch Art 1450–1900*, Royal Academy, London, 1929, no. 396. *Jongkind Tentoonstelling*, 1930, no. 28: Pulchri Studio, The Hague, and Rijksmuseum, Amsterdam. *Jongkind Tentoonstelling*, Stedelijk Museum, Amsterdam, 1948, no. 30. *Exposition Jongkind*, Palais des Beaux-Arts, Brussels, 1948–49, no. 18. *Exposition Jongkind*, Musée de l'Orangerie, Paris, 1949, no. 14.
COLLECTIONS: Gustave Tempelaere, Paris. Private collection; sold Sotheby's, London, April 26, 1967, no. 6 (illus.).

[18] Hefting, *Jongkind, sa vie*, nos. 332 (oil) and 349 (watercolor) (see "References"). The Mellon version and Hefting no. 332 are referred to in a letter of May 20, 1865, from the artist to Théophile Bascle, a collector in Bordeaux (Hefting, *Jongkind, sa vie*, p. 356).

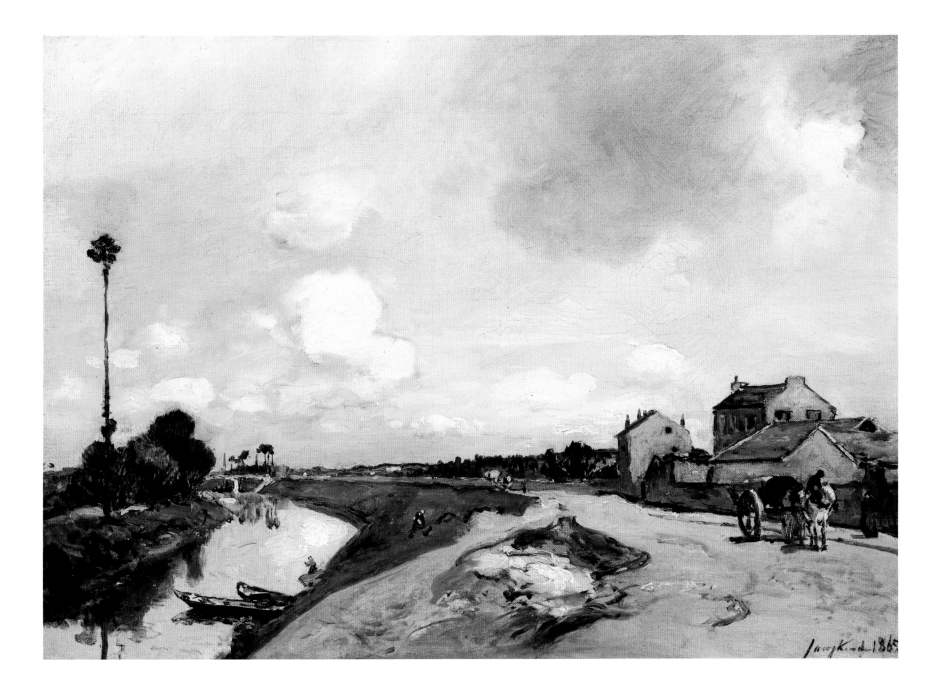

49

STANISLAS LEPINE (1835–1892)

One of numerous "little masters" of French landscape painting in the nineteenth century, Lépine played a small but not insignificant role in the evolution of Impressionism. His association with the movement was acknowledged when he was invited to participate in the first Impressionist exhibition of 1874. A pupil of Corot, Lépine had a style that was low keyed in accent and delicate in tone. For a time he received financial support from Count Doria, but his life was largely lived in near poverty.

23 *View of Paris*

Oil on canvas, 25.4 x 44.4 (10 x 17½)
Signed, lower right: *S. Lépine*
Acc. no. 83.30

Lépine's style has been described as being somewhere between Corot's and Jongkind's. Although he occasionally spent summers in Normandy, a very large proportion of his oeuvre is devoted to recording activity on the various waterways of Paris, as in this painting and the other three paintings in the Mellon collection (catalogue nos. 24–26). In the present work, Notre Dame Cathedral appears in the distance, screened in its lower part by the Pont d'Austerlitz; to the right is the Quai de la Rapée and to the left the grounds of the Salpêtrière Hospital. The artist may have executed this painting standing on the Pont de Bercy (erected 1864).

COLLECTIONS: DeLestrade. Galerie Schmit, Paris, until 1965.

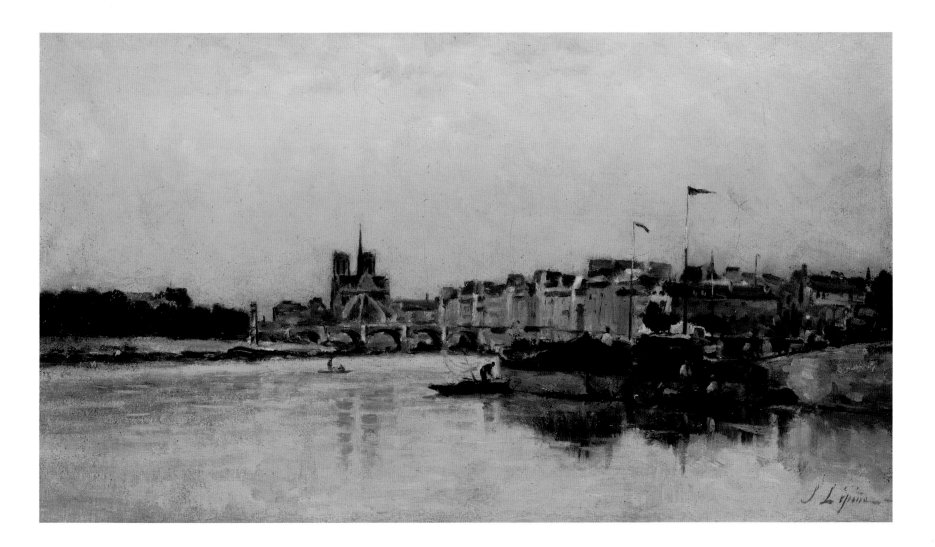

24 *The Seine at Charenton*, 1880

Oil on canvas, 24.2 x 37.5 (9$\frac{1}{2}$ x 14$\frac{3}{4}$)
Signed, lower right: *S. Lépine*
Acc no. 83.31

Lépine was represented in four of the Impressionist exhibitions held between 1874 and 1886, including that of 1880, also the date of this painting. It was executed at the site of the confluence of the Seine and Marne Rivers. Charenton, an eastern suburb of Paris just south of the Bois de Vincennes, is visible in the right middle distance.

EXHIBITIONS: *French Paintings from the Collection of Mr. and Mrs. Paul Mellon,* Virginia Museum of Fine Arts, April 4, 1967–June 5, 1968.

COLLECTIONS: Mrs. H. Abrahams. Arthur Tooth & Sons, London, until 1964.

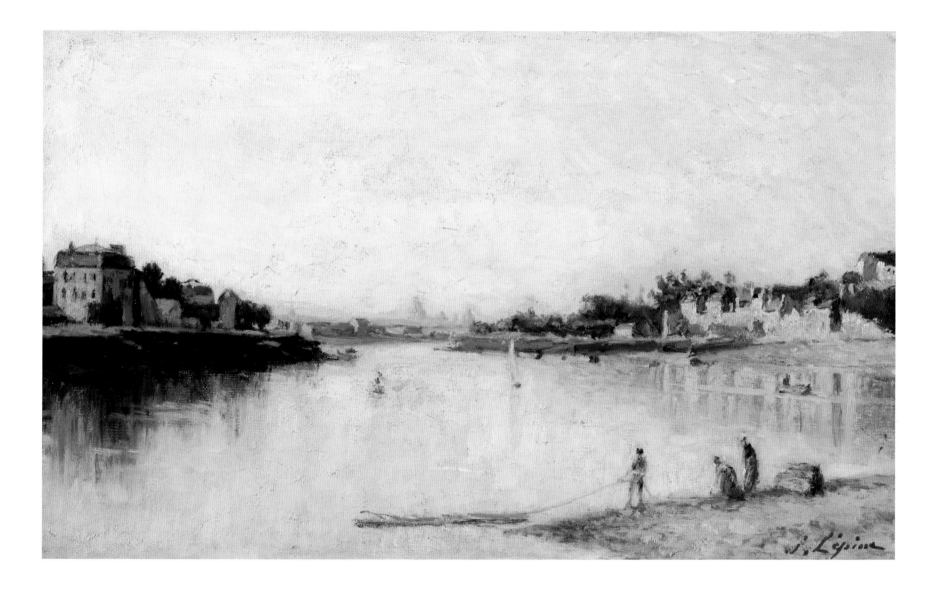

25 *The Bièvre, Paris*

Oil on canvas, 35.2 x 46.3 (13⁷⁄₈ x 18¹⁄₄)
Signed, lower left: *S. Lépine*
Acc. no. 83.32

The river Bièvre flows north through the eastern part of the left bank of Paris, emptying into the Seine at the Gare d'Austerlitz. It was noted for both its periodic flooding and unsavory stench, although it possessed a picturesque charm that was ignored by neither painters nor poets. The present painting probably depicts the Bièvre as it passes through the district of the Gobelins tapestry works. By the end of the nineteenth century only the northernmost segments of the river were still exposed, and by the eve of World War I it was entirely paved over.

COLLECTIONS: Mrs. Walter Feilchenfeldt, Zurich, until 1967.

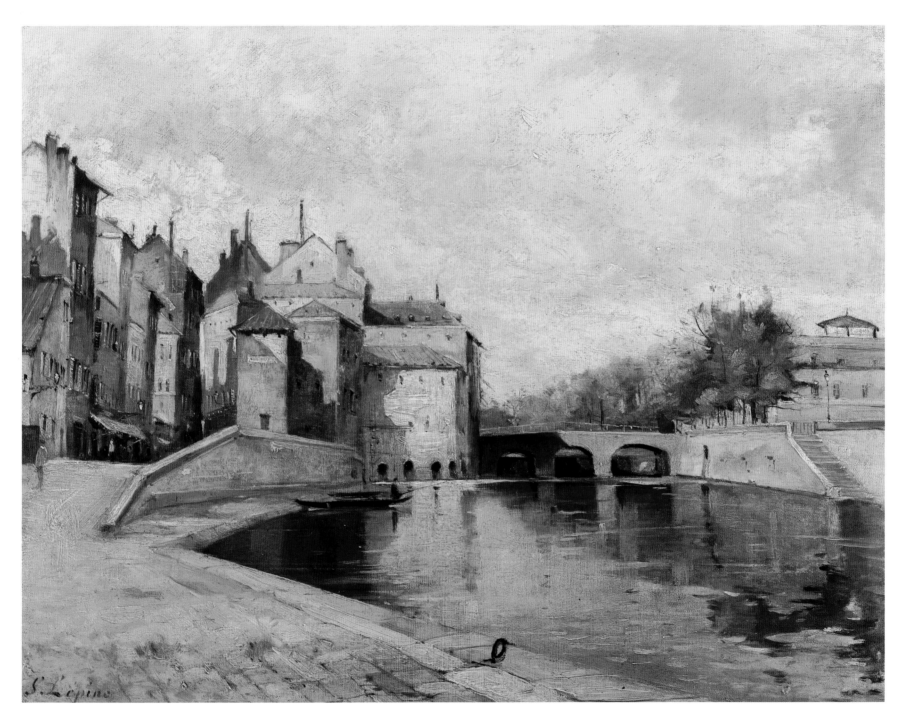

26 *The Dock at La Villette, Paris*

Oil on canvas, 51.1 x 91.4 (20⅛ x 36)
Signed, lower right: *S. Lépine*
Acc. no. 83.33

The Bassin de la Villette is a busy docking facility in northeast Paris, between the Ourcq and Saint Martin canals; the latter canal flows directly to the Seine.

EXHIBITIONS: *French Paintings from the Collections of Mr. and Mrs. Paul Mellon and Mrs. Mellon Bruce*, National Gallery of Art, Washington, D.C., March 17–May 1, 1966, no. 67 (illus.).

COLLECTIONS: Cabruja Collection, until 1921. Raoul Combe. Galerie Schmit, Paris, until 1965.

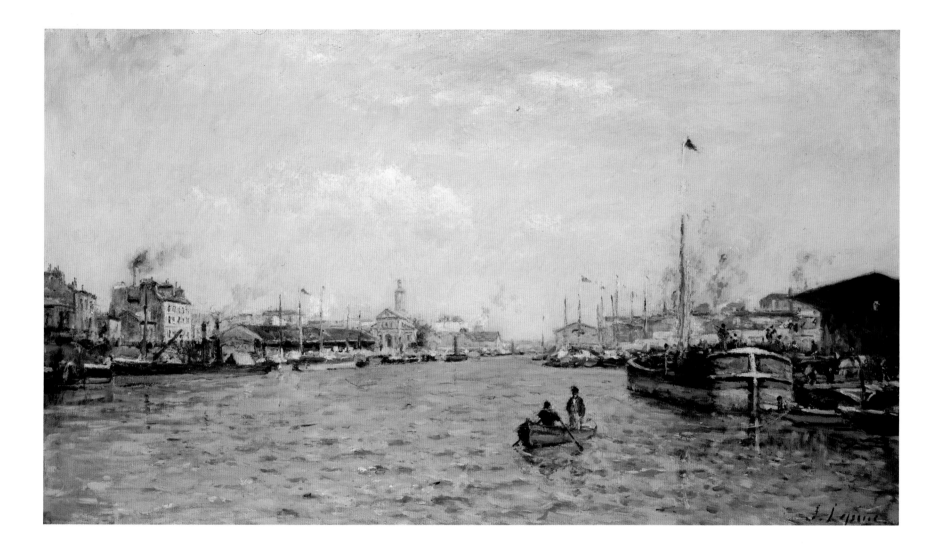

57

EDOUARD MANET (1832–1883)

Manet studied under Thomas Couture for six years, 1850–56; his training included much copying of old masters, especially the Spaniards Velazquez, Ribera, and Murillo. On leaving Couture he became increasingly preoccupied with a direct approach to immediate reality, both in choice of subject matter and method. His work possessed a freshness of touch and texture, and a virtual elimination of halftones that was shocking to most of his contemporaries but was an inspiration to young painters of the avant-garde, especially Monet, Renoir, and the other Impressionists. In the 1870s, partly under the influence of Monet and a pupil, Berthe Morisot, Manet adopted some of the methods of the Impressionists, including working out-of-doors and employing more positive, brighter color.

27 *On the Beach, Boulogne-sur-Mer,* 1869

Oil on canvas, 32 x 65 (12⅝ x 25⅝)
Signed, lower right: *Manet*
Acc. no. 85.498

Manet vacationed with his family at Boulogne-sur-Mer in July and August 1869. Among the many works he produced there were views from his hotel room, which faced the Channel boat-landing pier. The Mellon painting shows the beach from a lower vantage point. Eighteen preliminary sketches (Musée du Louvre, Paris) exist for this work.[19]

REFERENCES: Théodore Duret, *Histoire d'Edouard Manet et de son oeuvre* (Paris, 1902), no. 117. *Catalogue des tableaux formant la collection Faure* (Paris, 1902), no. 33. J. Meier-Graefe, *Edouard Manet* (Munich, 1912), pl. 76. *Kunst und Künstler* (1912), p. 144. E. Moreau-Nélaton, *Manet raconté par lui-même,* vol. 1 (Paris, 1926), p. 111, fig. 133, no. 123. A. Tabarant, *Manet—histoire catalographique* (Paris, 1931), no. 147. J. Meier-Graefe, "Le Centenaire de Manet," *Formes* (April 1932): 253. René Huyghe, "Manet Peintre," *L'Amour de l'Art* (May 1932), fig. 47. P. Jamot, G. Wildenstein, and M. L. Bataille, *Manet* (Paris, 1932), no. 166, fig. 316. A. Tabarant, *Manet et ses oeuvres* (Paris, 1932), p. 198, no. 147; 1947 ed., p. 166, no. 151. Robert Rey, *Manet* (Paris, 1938); English ed., London and Toronto, n.d., p. 137 (illus., overall and detail). L. Venturi, *Les archives de l'impressionnisme,* vol. 2 (Paris and New York, 1939), p. 192. M. Florisoone, *Manet* (Monaco, 1947), pp. xx, xxviii, 45 (illus.).

Maurice Bex, *Manet* (Paris, 1948), p. 53. J. Richardson, *Edouard Manet. Paintings and Drawings* (London, 1958), p. 13, pl 35. A. de Leiris, "Manet: sur la plage de Boulogne," *Gazette des Beaux-Arts,* 6th series, vol. 57 (Jan. 1961): 53–61. A. Bowness, "A note on Manet's compositional difficulties," *Burlington Magazine* 103 (June 1961): 276–77. R. Goldwater, "The Glory that was France," *Art News* (March 1966): 40 (illus.). D. Rouart and S. Orienti, *Tout l'oeuvre peint d'Edouard Manet* (Paris, 1970), no. 130 (illus.). D. Rouart and D. Wildenstein, *Edouard Manet, catalogue raisonné,* vol. 1 (Lausanne and Paris, 1975), no. 148 (illus.).

EXHIBITIONS: *Exposition posthume Manet,* Ecole des Beaux-Arts, Paris, 1884 (not in catalogue). *Tableaux de la Collection Faure,* Galerie Durand-Ruel (Paris, 1906), no. 11. Föreningen Fransk Konst, Stockholm, Copenhagen, Oslo, 1922, no. 10. *Oeuvres des XIXᵉ et XXᵉ Siècles,* Galerie Bernheim-Jeune, Paris, 1925, no. 77. *Manet,* Galerie Bernheim-Jeune, Paris, 1928, no. 17. *French Art,* Royal Academy, London, 1932, no. 458. *Manet,* Musée de l'Orangerie, Paris, 1932, no. 38. *Le Grand Siècle,* Galerie Rosenberg, Paris, 1936, no. 34. *Anthology, French Pictures from Private Collections,* Tooth & Sons, London, 1949, no. 3. *Landscape in French Art,* Royal Academy, London, 1949–50, no. 242. *Het Franse Lanschap van Poussin tot Cézanne,* Rijksmuseum, Amsterdam, 1951, no. 73. *The Pleydell-Bouverie Collection,* Tate Gallery, London, 1954, no. 25. *French Painting from the Collections of Mr. and Mrs. Paul Mellon and Mrs. Mellon Bruce,* National Gallery of Art, Washington, D.C., March 17–May 1, 1966, no. 46 (illus.). *Manet and Modern Paris,* National Gallery of Art, Washington, D.C., Dec. 5, 1982–March 6, 1983, no. 51 (illus.), color pl. II.

COLLECTIONS: Sold by Manet to Paul Durand-Ruel, Paris, 1872. J. B. Faure, Paris, 1873. Galerie Durand-Ruel, Paris, 1907, New York, 1909. O. Nielsen, Oslo. J. Laroche, Paris, A. Morhange, Paris. Mrs. A. E. Pleydell-Bouverie, London. Galerie des Arts Anciens et Modernes, Liechtenstein, until 1960.

[19] D. Rouart and D. Wildenstein, *Edouard Manet,* vol. 2, nos. 146–63 (see "References").

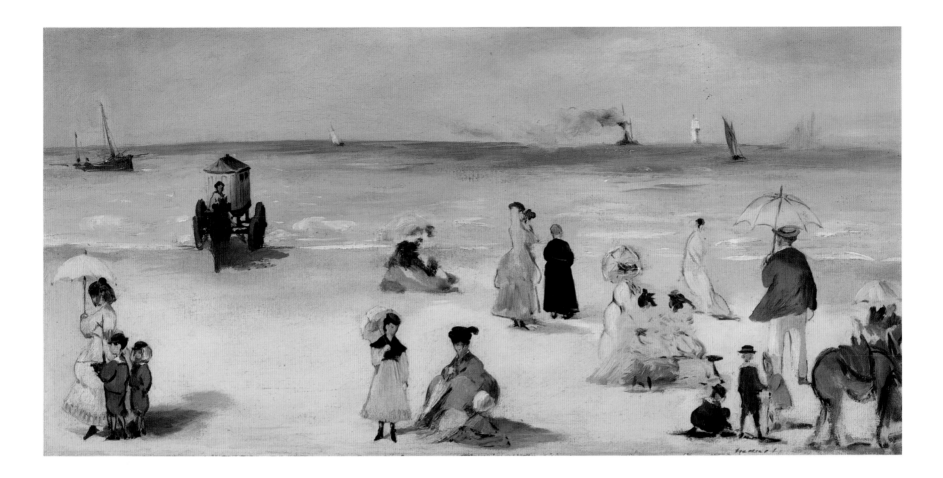

CLAUDE MONET (1840–1926)

Although he was born in Paris, Monet spent his youth in Le Havre. His interest in landscape painting was stimulated by Boudin, with whom he became acquainted while still in his teens, and by Jongkind, whom he met in 1862. His association with the other future Impressionists— Renoir, Sisley, Bazille, Pissarro—took place in Paris in the 1860s. Of all the Impressionists Monet remained the most consistent in his dedication to the fundamental goal of transcribing visual sensations, even though his evolution—from early Impressionism through the works of the '80s and from his serial paintings of the '90s to the Giverny waterlilies—was one of remarkable dynamism.

28 *Camille at the Window, Argenteuil,* 1873

Oil on canvas, 60.3 x 49.8 (23³/4 x 19⁵/8)
Estate stamp, lower left: *Claude Monet*
Acc. no. 83.38

Monet rented the house shown in this painting from 1871 to 1874, when financial straits forced him to move to a simpler dwelling in Argenteuil. The window at which his wife, Camille, stands faced a fairly extensive garden.[20]

REFERENCES: Daniel Wildenstein, *Claude Monet*, vol. 1 (Lausanne and Paris, 1974), no. 287 (illus.). Paul Hayes Tucker, *Monet at Argenteuil* (New Haven, 1982), pp. 131ff., pl. XXIV, p. 124.

EXHIBITIONS: *Claude Monet: Exposition Rétrospective*, Musée de l'Orangerie, Paris, 1931, no. 21. *Centenaire de Claude Monet*, Galerie André Weil, Paris, Jan. 30–Feb. 21, 1940, no. 4. *Claude Monet*, Galerie Durand-Ruel, Paris, May 22–Sept. 30, 1959, no. 10. *Degas*, Virginia Museum of Fine Arts, May 23–July 9, 1978.

COLLECTIONS: Michel Monet, Giverny. Wildenstein & Co., New York, until 1968.

[20] Cf. Wildenstein, *Claude Monet*, vol. 1, nos. 284–86 (see "References").

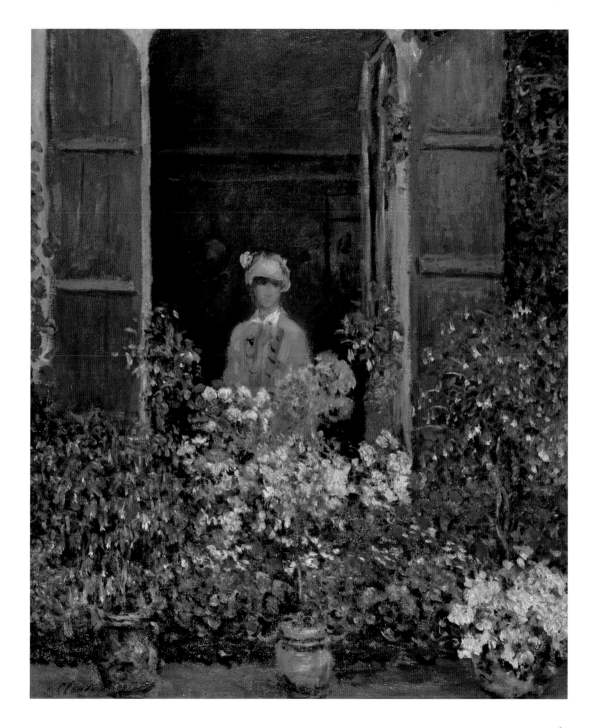

29 *Field of Poppies, Giverny*, 1885

Oil on canvas, 60 x 73 (23⅝ x 28¾)
Signed and dated, lower left: *Claude Monet 85*
Acc. no. 85.499

This work is one of four paintings of poppy fields in and around Giverny executed in the summer of 1885, two years after the artist settled there. The view is toward the village; just to the right of the houses in the middle distance is the future site of the large studio in which Monet painted his celebrated waterlilies.

REFERENCES: H. Adhémar, *Monet, Peintures* (Paris, 1950), p. 13, pl. XIII. Daniel Wildenstein, *Claude Monet*, vol. 2 (Lausanne and Paris, 1979), no. 997 (illus.).

EXHIBITIONS: *The Impressionists of Paris*, no. 212: American Art Galleries, New York, April 1886; National Academy of Design, New York, May–June, 1886. *Monet, Pissarro, Renoir, et Sisley*, Galerie Durand-Ruel, Paris, April 1899, no. 22. *Pictures by Boudin, Cézanne, Degas, Manet, Monet, Morisot, Pissarro, Renoir, Sisley*, Grafton Galleries, London, January–February 1905, no. 129. *Monet*, Galerie Durand-Ruel, Paris, 1928, no. 47. *Impressionisten*, Kunsthalle, Basel, 1949, no. 149. *Les environs de Paris*, Musée de Sceaux, 1951, no. 82. *French Paintings from the Collections of Mr. and Mrs. Paul Mellon and Mrs. Mellon Bruce*, National Gallery of Art, Washington, D.C., March 17–May 1, 1966, no. 87 (illus.).

COLLECTIONS: Bought from Monet by Durand-Ruel (?), September 1885. Alden Weyman Kingman, New York, 1886. Durand-Ruel, 1896. Sam Salz, New York, until 1963.

BERTHE MORISOT (1841–1895)

Berthe Morisot took up painting in her teens. Corot, to whom she was introduced in 1860, had a strong influence on her; a few years later she was accepted in the Paris Salon, where she was represented by some of her first landscapes. The crucial turning point in her career, however, occurred in 1868 when she met Manet, under whose influence her manner of painting changed markedly. She also became attracted to the human figure in casual poses, especially in scenes of everyday family life, which remained her primary subject for the rest of her life. Through Manet she met the Impressionists, and she showed her work in almost all of the Impressionist exhibitions between 1874 and 1886.

30 *On the Beach*, 1873

Oil on canvas, 24.1 x 50.2 (9½ x 19¾)
Signed, lower right: *Berthe Morisot*
Acc. no. 83.39

This scene was painted at the beach of Les Petites Dalles near Fécamp in Normandy, where the artist stayed in 1873, the last year she showed at the Salon. Two other views of Les Petites Dalles, also from 1873, are the exact size as the present work.[21] The probable source of inspiration for all three paintings was Manet's *On the Beach, Boulogne-sur-Mer*, also in the Mellon collection (catalogue no. 27).

REFERENCES: L. Rouart, *Berthe Morisot* (Paris, 1941), illus. M.-L. Bataille and Georges Wildenstein, *Berthe Morisot* (Paris, 1961), no. 28, fig. 89.

EXHIBITIONS: *The Pleydell-Bouverie Collection*, Tate Gallery, London, 1954, no. 28. *Berthe Morisot*, Wildenstein & Co., London, 1961, no. 5. *French Marine Paintings of the Nineteenth Century*, Museum of Fine Arts, St. Petersburg, Florida, March 16–May 5, 1985, no. 17 (illus.).

COLLECTIONS: Anonymous Sale, Paris, March 24, 1875, no. 25. M[lle] de Jaegher, Roubaix. Albert Pra, Paris; Vente Pra, June 17, 1938, no. 45 (illus.). Arthur Tooth & Sons, London. Hon. Mrs. A. E. Pleydell-Bouverie; sold Sotheby's, London, July 3, 1968, no. 12 (illus.).

[21] They are catalogued as nos. 29 and 30 in Bataille and Wildenstein, *Berthe Morisot* (see "References").

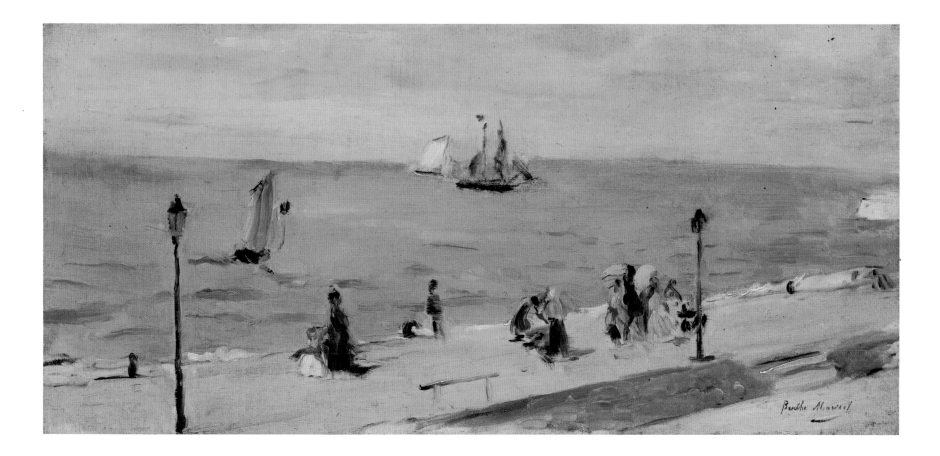

31 *The Jetty*, 1875

Oil on canvas, 24.2 x 51.4 (9½ x 20¼)
Signed, lower left: *Berthe Morisot*
Acc. no. 83.41

During the summer of 1875 Morisot traveled to England, staying part of the time on the Isle of Wight, which most likely is the subject of this painting.

REFERENCES: M.-L. Bataille and Georges Wildenstein, *Berthe Morisot* (Paris, 1961), no. 55, fig. 109.

EXHIBITIONS: *Société anonyme des artistes peintres, sculpteurs, graveurs, etc., 2ᵉ Exposition de Peinture* (second Impressionist exhibition), 11 rue le Peletier, Paris, April 1876. *Berthe Morisot*, Galerie Boussod et Valadon, Paris, 1892, no. 14. *Berthe Morisot*, Galerie Durand-Ruel, Paris, 1902, no. 53. *Berthe Morisot*, Galerie Bernheim-Jeune, Paris, 1929, no. 25. *French Marine Paintings of the Nineteenth Century*, Museum of Fine Arts, St. Petersburg, Florida, March 16–May 5, 1985, no. 18 (illus.).

COLLECTIONS: Anonymous Sale, Paris, March 29, 1879, no. 76. Victor Chocquet, Paris; sold July 1–4, 1899, Paris, no. 86. M. Pridonoff. Private collection; sold Sotheby's, London, December 4, 1968, no. 19 (illus.).

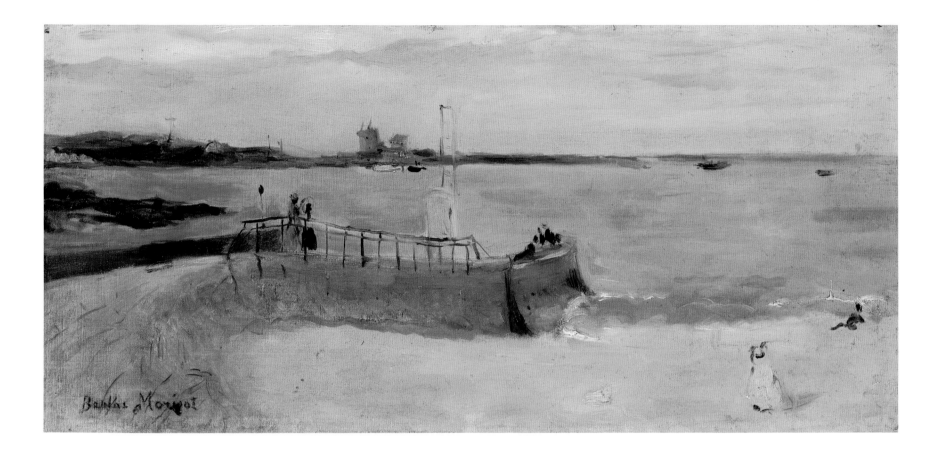

32 *Young Woman Watering a Shrub,* 1876

Oil on canvas, 40 x 31.7 (15³/₄ x 12¹/₂)

Signed, lower left: *Morisot*

Acc. no. 83.40

REFERENCES: M.-L. Bataille and Georges Wildenstein, *Berthe Morisot* (Paris, 1961), no. 62, pl. 30.

EXHIBITIONS: *Berthe Morisot*, Galerie Bernheim-Jeune, Paris, 1929, no. 94. *Berthe Morisot*, Musée de l'Orangerie, Paris, 1941, no. 22.

COLLECTIONS: Marcel Guérin. Galerie Schmit, Paris, until 1967.

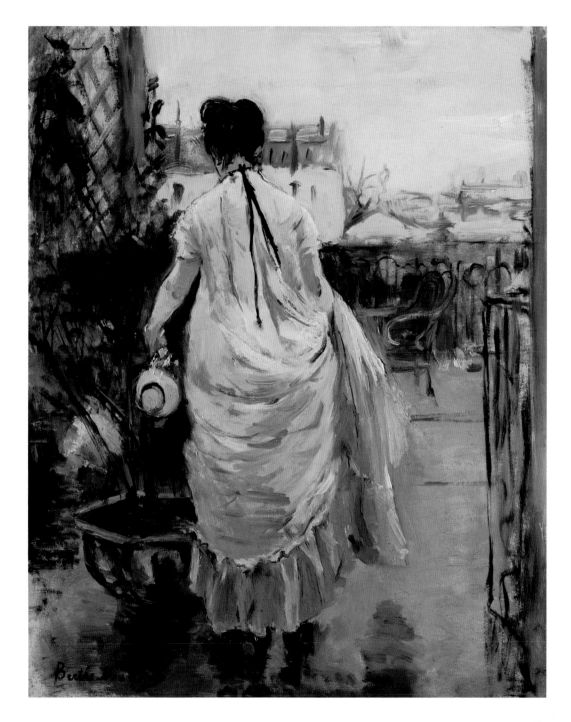

CAMILLE PISSARRO (1830–1903)

Pissarro was born in the West Indies, son of a Creole mother and a father of Portuguese-Jewish descent. He moved to Paris in 1855. An important force in the development of Impressionism, Pissarro was the only Impressionist to show in all eight of the group exhibitions. His flexibility and receptivity to new ideas and approaches led him to alter his style more than once in later years, most notably under the influence of Seurat in the '80s. A person of great integrity and moral fiber, he played a significant role in countering the divisive forces that threatened the Impressionist movement from time to time.

33 *Coconut Palms by the Sea, St. Thomas*, 1856

Oil on canvas, 26.6 x 34.9 (10½ x 13¾)

Signed and dated, lower left: *C. Pizarro. Paris 1856*. Inscribed on back: *A mon cher neveu Emmanuel Pichon / Souvenir du 25 Mars 1906 / Anton Melbye*

Acc. no. 83.45

This painting and *Landscape, St. Thomas* (catalogue no. 34) are among the very few surviving scenes of St. Thomas painted by Pissarro shortly after settling permanently in France. Located in the Antilles, St. Thomas was at the time a colony of Denmark.

REFERENCES: John Rewald, "L'oeuvre de jeunesse de Camille Pissarro," *L'Amour de l'Art* (April 1936): 141, 143 (illus.). L. R. Pissarro and Lionello Venturi, *Camille Pissarro*, vol. 1 (Paris, 1939), p. 78, no. 8; vol. 2, pl. 2. John Rewald, *Pissarro* (London and New York, 1963), p. 11 (illus.). P. Pool, *Impressionism* (London and New York, 1967), pp. 38–39 (illus.).John Rewald, *The History of Impressionism*, 4th rev. ed. (New York, 1973), p. 18 (illus.). Kermit Swiler Champa, *Studies in Early Impressionism* (New Haven and London, 1973), p. 67, fig. 90. John Rewald, "Theo van Gogh, Goupil and the Impressionists," *Gazette des Beaux-Arts*, 6th series, vol. 81 (Jan. 1973): 18 (illus.).

EXHIBITIONS: *Exposition Camille Pissarro*, Galerie Durand-Ruel, Paris, June 26–Sept. 14, 1956, no. 3. *Camille Pissarro*, Kunstmuseum, Berne, Jan. 19–March 10, 1957, no. 4, pl. I. *Pissarro*, no. 1 (illus.): Hayward Gallery, London, Oct. 30, 1980–Jan. 11, 1981; Galeries Nationales du Grand Palais, Paris, Jan. 30–April 27, 1981; Museum of Fine Arts, Boston, May 19–Aug. 9, 1981.

COLLECTIONS: Anton Melbye. Emmanuel Pichon, Le Pecq. Mme Jules Joets. Wildenstein & Co., New York, until 1960.

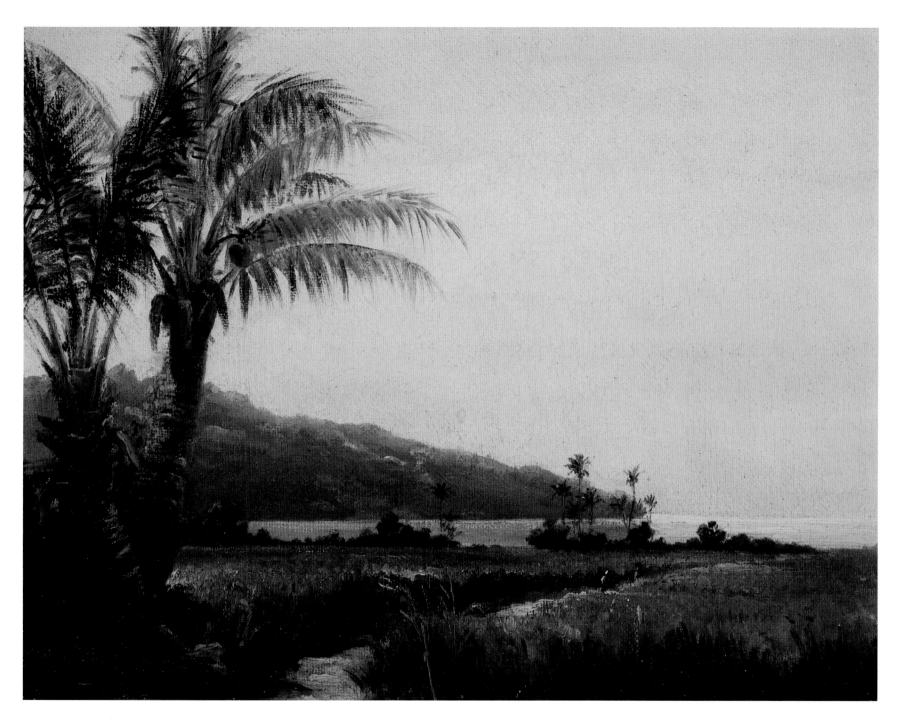

CAMILLE PISSARRO

34 *Landscape, St. Thomas*, 1856

Oil on canvas, 46.3 x 38.1 (18¼ x 15)
Signed and dated, lower right: *C. Pizarro 1856*
Acc. no. 83.46

EXHIBITIONS: *The European Vision of America*, no. 261 (illus.): National Gallery
of Art, Washington, D.C., Dec. 7, 1975–Feb. 15, 1976; Cleveland Museum of Art,
April 28–Aug. 8, 1976; Galeries Nationales du Grand Palais, Paris, Sept. 17, 1976–
Jan. 3, 1977.
COLLECTIONS: Private collection; sold Sotheby's, London, December 1, 1965, no.
147 (illus.).

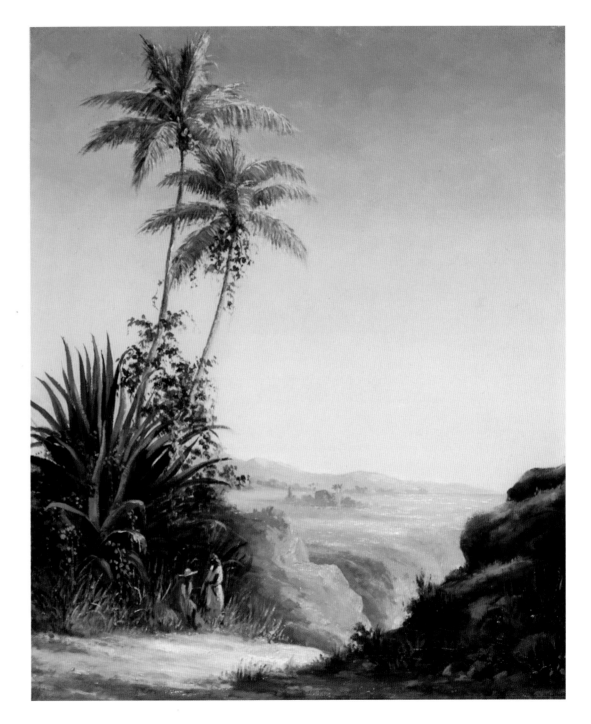

35 *The Quai du Pothuis, Pontoise*, 1872

Oil on canvas, 45.1 x 55.2 (17³/₄ x 21³/₄)
Signed and dated, lower left: *C. P. Pissarro 1872*
Acc. no. 83.44

Views of Pontoise and its environs were among Pissarro's most frequent subjects after 1866, the year he settled in the older quarter of the town known as L'Hermitage, which lies to the northeast and borders the Oise River.

REFERENCES: L. R. Pissarro and Lionello Venturi, *Camille Pissarro*, vol. 1 (Paris, 1939), p. 105, no. 189; vol. 2, pl. 38.
COLLECTIONS: Paul Cassirer, Berlin. Dr. Paul Steiner, Zurich. Hector Brame, Paris, until 1962.

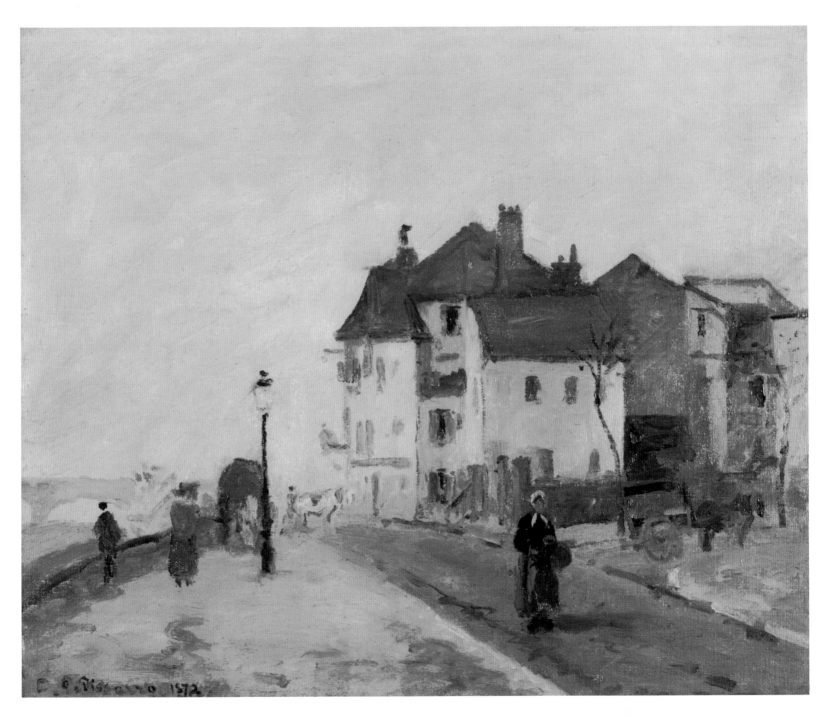

75

PIERRE-AUGUSTE RENOIR (1841–1919)

Renoir's family moved from Limoges to Paris when the artist was three years old. He took up painting after serving an apprenticeship as a porcelain decorator and in 1862 met Monet, Sisley, and Bazille at the studio of Charles Gleyre. He practiced plein-air painting in the late 1860s, often side by side with Monet, and in the '70s he brought to maturity a style of brilliant color, luminosity, and unselfconscious lyricism. After a trip to Italy in the early 1880s he moved abruptly toward a more linear idiom, one strongly dependent on compositional devices of an almost logical severity. This phase, which was of short duration, was followed by a late style characterized by monumentality and earthy vigor, along with rich and sonorous color harmonies. Even before he settled in southern France in 1906 he was suffering from the crippling effects of arthritis.

36 *Pensive (La Songeuse)*, 1875

Oil on paper on canvas, 46 x 38.1 (18⅛ x 15)
Signed, upper right: *Renoir*
Acc. no. 83.47

The model for this painting was Nini Lopez, who began posing for Renoir in the preceding year, most notably in *La Loge*, which was exhibited in the first Impressionist exhibition, 1874, and is now in the Courtauld Institute Galleries, London. The present painting is probably included among the works owned by a Mr. Deudon; they are referred to in a letter from Renoir to Durand-Ruel in February 1899.[22]

REFERENCES: Lionello Venturi, *Les archives de l'impressionnisme*, vol. 1 (Paris, New York, 1939), p. 152. François Daulte, *Auguste Renoir, catalogue raisonné*, vol. 1 (Lausanne, 1971), no. 149 (illus.). Elda Fezzi, *L'opera completa di Renoir nel periodo impressionista* (Milan, 1972), no. 173 (illus.). Bruno F. Schneider, *Renoir*, rev. ed. (New York, 1984), p. 12 (illus.).

EXHIBITIONS: *Grands Maîtres du XIXᵉ Siècle*, Galerie Paul Rosenberg, Paris, May 3–June 3, 1922, no. 73. *Oeuvres d'art des XVIIIᵉ, XIXᵉ siècles*, Chambre Syndicale de la Curiosité et des Beaux Arts, Paris, April 25–May 15, 1923, no. 216. *Renoir*, Musée de l'Orangerie, Paris, 1933, no. 23 (illus.). *Hommage à Renoir*, Galerie Durand-Ruel, Paris, May 30–Oct. 15, 1958, no. 6 (illus.). *French Paintings from the Collection of Mr. and Mrs. Paul Mellon*, Virginia Museum of Fine Arts, April 4, 1967–June 5, 1968.

COLLECTIONS: M. Deudon, Nice; sold 1899. Paul Rosenberg & Co., Paris. Mᵐᵉ Georges Menier; sold Palais Galliera, Paris, June 20–21, 1966.

[22] Cf. Lionello Venturi, *Les archives . . .*, p. 152 (see "References").

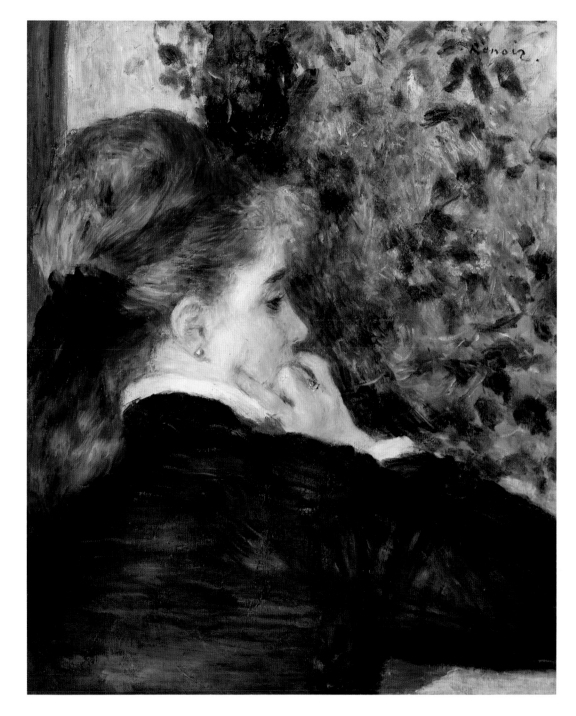

37 *The Artist's Son, Jean, Drawing*, 1901

Oil on canvas, 45.1 x 54.5 (17³/₄ x 21¹/₂)
Signed and dated, lower right: *Renoir. 01*
Acc. no. 83.48

In a 1952 letter Jean Renoir reminisced as follows: "I was myself exactly seven when the painting was done. I had caught a cold and could not go to school and my Father took the opportunity to use me as a model. To keep me quiet he suggested that a pencil and a piece of paper should be given to me and he convinced me to draw figures of animals while he was himself drawing me."[23]

REFERENCES: G. Rivière, *Renoir et ses Amis* (Paris, 1921), p. 114. Bernard Denvir, *Renoir*, vol. 2 (London, 1954), pp. 3 (illus. pl. 1), 24. *Connoisseur*, American edition 138/555 (Sept. 1956): 65 (review of Denvir, *Renoir*). Barbara Ehrlich White, *Renoir, His Life, Art, and Letters* (New York, 1984), pp. 220, 223 (illus.).

EXHIBITIONS: Edinburgh Festival, 1953. *Renoir*, The Arts Council of Great Britain, The Tate Gallery, London, 1953, no. 46a. *French Paintings from the Collections of Mr. and Mrs. Paul Mellon and Mrs. Mellon Bruce*, National Gallery of Art, Washington, D.C., March 17–May 1, 1966, no. 106 (illus.).

COLLECTIONS: Alfred Flechtheim, Berlin; sold 1920s. Sir Thomas Barlow. Basil Barlow. Thomas Agnew & Sons, London, until 1961.

[23] Jean Renoir to John Roberts of Ganymed Press, London, Jan. 1, 1952, Collections Division files, Virginia Museum of Fine Arts, Gift of Mrs. Ann Baer, Richmond-on-Thames, England. Ganymed Press published a color reproduction of this painting.

79

ALFRED SISLEY (1839–1899)

Born in Paris of English parents, Sisley, like Renoir, Monet, and Bazille, studied in Charles Gleyre's studio in the early 1860s. He participated in the first Impressionist group show, as well as some later ones. Except for two visits to England he worked in and around Paris, later settling in Moret-sur-Loing, at the edge of Fontainebleau forest, where he died. His work is remarkable for its purity and consistency of allegiance to the Impressionist style of the 1870s.

38 *Fish on a Plate,* 1865–67

Oil on canvas, 45.7 x 55.9 (18 x 22)
Signed, lower left: *Sisley*
Acc. no. 83.50

Only nine still lifes by Sisley are known, four from in or around the year 1867, one from 1875 (catalogue no. 40), and two each from 1876 and 1888.[24]

REFERENCES: G. Geffroy, *Sisley* (Paris, 1923), p. 22. G. Geffroy, *Sisley* (Paris, 1927), p. 23. G. Bazin, *L'époque impressionniste* (Paris, 1947), pl. 14. François Daulte, *Alfred Sisley, catalogue raisonné de l'oeuvre peint* (Lausanne, 1959), no. 6 (illus.).

EXHIBITIONS: *Fondation Rodolphe Staechelin: de Corot à Picasso,* Musée d'Art Moderne, Paris, April 10–June 28, 1964, no. 7. *Impressionnistes,* Galerie Beyeler, Basel, Oct.–Nov. 18, 1967, no. 31 (illus.).

COLLECTIONS: Rudolf Staechelin, Basle. Thannhauser, Lucerne, 1921. George Viau, Paris. Comtesse de Behague, Paris. Marquise de Gannay, Paris. Comte François de Gannay, Paris. Crane Kalman Gallery, London, until 1969.

[24] Daulte, *Alfred Sisley,* nos. 5–8, 186, 233–34, 661–62 (see "References").

39 *The Thames at Hampton Court*, 1874

Oil on canvas, 34.9 x 59.7 (13 3/4 x 23 1/2)
Signed, lower right: *Sisley*
Acc. no. 83.51

Sisley was represented by five paintings in the first Impressionist exhibition, which was held on the premises of the photographer Nadar from April 15 to May 15, 1874. In July of that year he was invited by the singer Jean-Baptiste Faure to visit England. There, until the end of October, he executed a number of views of the Thames. Another version of the same view is known (Sterling and Francine Clark Art Institute, Williamstown, Massachusetts).

REFERENCES: Théodore Duret, *Histoire des peintres impressionnistes* (Paris, 1906), p. 83 (illus.). François Daulte, *Alfred Sisley, catalogue raisonné de l'oeuvre peint* (Lausanne, 1959), no. 116 (illus.).

EXHIBITIONS: *Exposition des Tableaux de Monet, Pissarro, Renoir et Sisley*, Galerie Durand-Ruel, Paris, 1899, no. 115. *Pictures by Boudin, Cézanne, Degas, Manet, Monet, Morisot, Pissarro, Renoir and Sisley*, Grafton Galleries, London, 1905, no. 288. *Sisley*, Galerie Durand-Ruel, Paris, 1937, no. 2. *Naissance de l'Impressionnisme*, Galerie de la Gazette des Beaux-Arts, Paris, 1937, no. 77 (illus.). *French Paintings from the Collection of Mr. and Mrs. Paul Mellon*, Virginia Museum of Fine Arts, April 4, 1967–June 5, 1968.

COLLECTIONS: Galerie Durand-Ruel, Paris; purchased from the artist April 29, 1890. Abbé Gauguin, Paris, 1937. Galerie Durand-Ruel, Paris. Alfred Lindon, Paris. M^me Alfred Lindon, Paris. M. Knoedler & Co., New York. Mr. and Mrs. Lester Avnet, Great Neck, Long Island; sold Parke-Bernet, New York, October 14, 1965, no. 104 (illus.).

40 *Wild Flowers,* ca. 1875

Oil on canvas, 65.4 x 50.5 (25³/4 x 19⁷/8)
Signed, bottom right: *Sisley*
Acc. no. 85.500

Of the nine still lifes known to have been painted by Sisley, this example is the only flower subject.[25]

REFERENCES: V. Gilardoni, *L'Impressionismo* (Milan, 1954), pl. 92. François Daulte, "Découverte de Sisley," *Connaissance des Arts* 60 (Feb. 1957): 51 (illus.). François Daulte, *Alfred Sisley, catalogue raisonné de l'oeuvre peint* (Lausanne, 1959), no. 186 (illus.).

EXHIBITIONS: *Impressionisten*, Kunsthalle, Basel, Sept. 1949, no. 92 (illus.). *Magic of Flowers*, Wildenstein & Co., New York, April–May 1954, no. 74. *A World of Flowers, Paintings and Prints*, Philadelphia Museum of Art, May–June 1963. *French Paintings from the Collections of Mr. and Mrs. Paul Mellon and Mrs. Mellon Bruce*, National Gallery of Art, Washington, D.C., March 17–May 1, 1966, no. 74 (illus.).

COLLECTIONS: Galerie Durand-Ruel, Paris; bought from the artist on February 27, 1882. F. Mendelssohn-Bartholdy, Berlin; bought from Durand-Ruel on October 28, 1907. Lucas Lichtenhan, Basel. Werner Feuz, Montreux. Wildenstein & Co., New York. Mrs. Pamela Woodworth Combemale, New York; sold Christie's, Nov. 27, 1964, no. 41 (color illus.).

[25] Daulte, *Alfred Sisley*, no. 186; see p. 347 for index of still lifes (see "References").

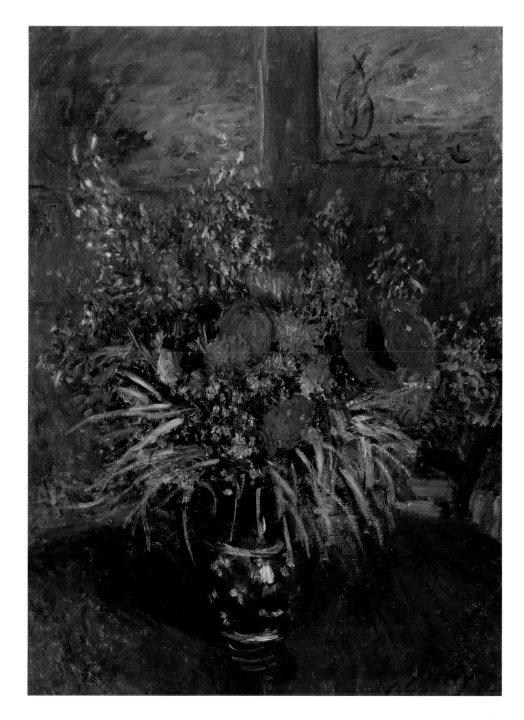

41 *The Watering Pond at Marly with Hoarfrost,* 1876

Oil on canvas, 37.8 x 54.9 (14⁷/₈ x 21⁵/₈)
Signed and dated, lower right: *Sisley 76*
Acc. no. 83.52

From 1875 to 1877 Sisley lived in Marly-le-Roi and painted there and in other towns in the region, especially Louveciennes and Bougival. The watering pond at Marly is the subject of twelve paintings dating between 1873 and 1876.[26] In early 1876 Sisley painted scenes of flooding at Marly, at least one of which he included in the second Impressionist group show in April of that year.

REFERENCES: François Daulte, *Alfred Sisley, catalogue raisonné de l'oeuvre peint* (Lausanne, 1959), no. 244 (illus.). Linda Walters, "The West Wing: A Grand Tradition Continued," *Arts in Virginia* 23/1–2 (1982–83): 33 (color illus.).

EXHIBITIONS: *French Paintings from the Collections of Mr. and Mrs. Paul Mellon and Mrs. Mellon Bruce,* National Gallery of Art, Washington, D.C., March 17–May 1, 1966, no. 76 (illus.).

COLLECTIONS: François Depeaux, Rouen; sold Galerie Georges Petit, Paris, May 13–June 1, 1906, no. 57. Galerie Durand-Ruel, Paris; sold November 17, 1913. Paul Cassirer, Berlin. Dr. Curt Hirschland, Essen. Mᵐᵉ Hirschland, New York. Private collection, Paris. Arthur Tooth & Sons, Ltd., London, until 1963.

[26] Daulte, *Alfred Sisley,* p. 346 (see "References").

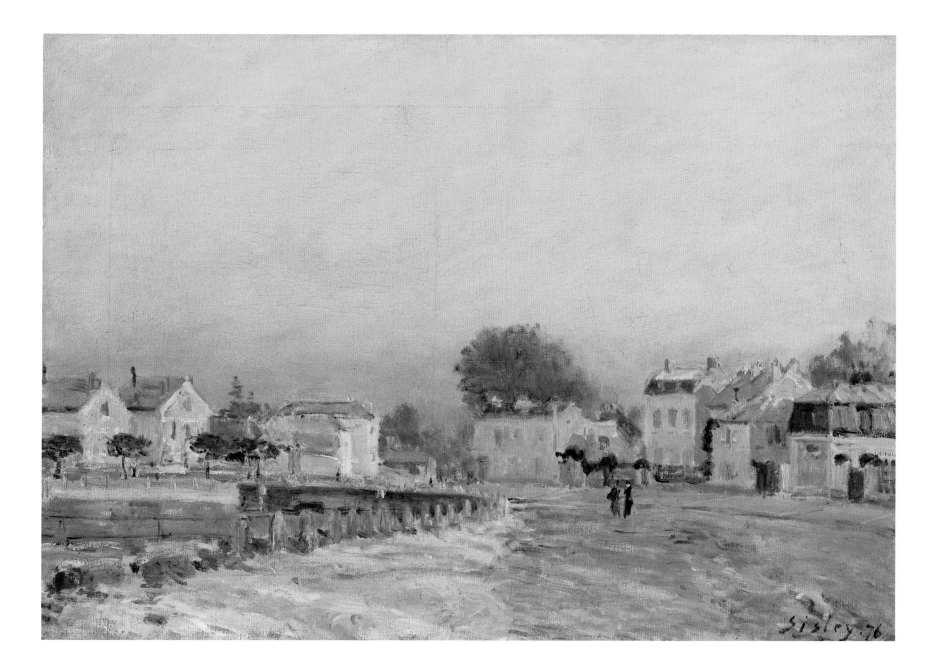

87

JAMES TISSOT (1836–1902)

Tissot debuted at the Paris Salon in 1859 with five works that were remarkable for their diversity: a snow scene with figures in sixteenth-century costume, two studies for stained-glass windows, and two portraits. He achieved considerable success in Paris with his scenes of fashionable life, but after serving in the Franco-Prussian War he moved to London, where he established a position of eminence as painter and etcher. Following a dramatic religious conversion in 1886, he undertook the project of illustrating the Bible, traveling to the Holy Land from October of that year to March 1887. On the basis of drawings and photographs made there he produced a large number of watercolor and gouache paintings of New Testament subjects. These works were exhibited publicly and later reproduced in two volumes, which had wide circulation. The last four years of his life were devoted to a similar series on the Old Testament, completed by 1902 but published posthumously.

42 *Mrs. Newton with a Child by a Pool,*
ca. 1877–78

Oil on mahogany panel, 32.4 x 42.5 (12³/₄ x 16³/₄)
Not signed
Acc. no. 85.53

In 1871 Kathleen Irene Ashburnham Kelly married Isaac Newton, a surgeon in the Indian Army, but they were divorced shortly afterwards. She and two children, born out of wedlock, lived with Tissot from 1876 until her death in 1882 at the age of 28. During those years she was the artist's most frequent model. A larger, more finished version of this work is known (fig. 4).[27]

EXHIBITIONS: *Mary Cassatt Among the Impressionists,* Joslyn Art Museum, Omaha, April 10–June 1, 1969, no. 21 (illus.; exhibited as by Mary Cassatt).
COLLECTIONS: George A. van Peterffy. Hans Horst, Hamburg. Hirschl & Adler Galleries, New York. Mr. and Mrs. Lester Avnet, Great Neck, Long Island, until 1969.

4. *Mrs. Newton with a Child by a Pool*, oil on canvas, 43.2 x 53.3 (17 x 21), signed lower right *J. J. Tissot*; present location unknown. (Photograph courtesy Schweitzer Gallery, Inc., New York.)

[27] See Michael Wentworth, *James Tissot* (Oxford, 1984), no. 135; and the exhibition catalogue *James Jacques Joseph Tissot: A Retrospective Exhibition,* 1968, no. 25 (n.p.): Museum of Art, Rhode Island School of Design; Art Gallery of Ontario, Toronto, where the child is tentatively identified as Mrs. Newton's son, Cecil George, born March 1876.

HENRI DE TOULOUSE-LAUTREC (1864–1901)

Lautrec's precocious talent was manifest from an early age. In 1882 he moved from Albi, his place of birth, to Paris, and from 1885 he maintained his own studio in Montmartre. He exhibited at the Salon des Indépendants from 1889. As an artist Lautrec possessed extraordinary gifts as draftsman and candid observer. His influence on the next generation was pervasive.

43 *At the Bar,* ca. 1886

Oil on canvas, 55.2 x 41.9 (21¾ x 16½)
Artist's stamp, lower left: *T-L*
Acc. no. 83.54

This painting has been related to a drawing that served as an illustration for an issue of the *Courrier Français* of September 26, 1886.[28] If this is correct, the work dates from shortly after the artist established his studio in Montmartre. The figure standing at the bar, to the left, undoubtedly represents the artist.

REFERENCES: M. Joyant, *Henri de Toulouse-Lautrec. Peintre* (Paris, 1926), p. 263. J. Lassaigne, *Toulouse-Lautrec* (Paris, 1939), p. 72 (illus.). L. Borgese, *Toulouse-Lautrec* (Milan, 1945), pl. IV. "Soirs de Paris," *Connaissance des Arts* 8 (Oct. 15, 1952): 37 (illus.). M. G. Dortu, *Toulouse-Lautrec et son oeuvre*, vol. 2 (New York, 1971), no. P.288, pp. 130, 131 (illus.).

EXHIBITIONS: *French Paintings from the Collections of Mr. and Mrs. Paul Mellon and Mrs. Mellon Bruce*, National Gallery of Art, Washington, D.C., March 17–May 1, 1966, no. 149 (illus.). *French Paintings from the Collection of Mr. and Mrs. Paul Mellon*, Virginia Museum of Fine Arts, April 4, 1967–June 5, 1968.

COLLECTIONS: Manzi, Paris. Georges Bernheim, Paris. Mᵐᵉ Roy, Paris. Georges Bernheim, Paris. Arthur Sachs, Paris. Sam Salz, New York, until 1961.

[28] Dortu, *Toulouse-Lautrec*, vol. 5, no. D. 2.965, pp. 482, 483 (illus.) (see "References").

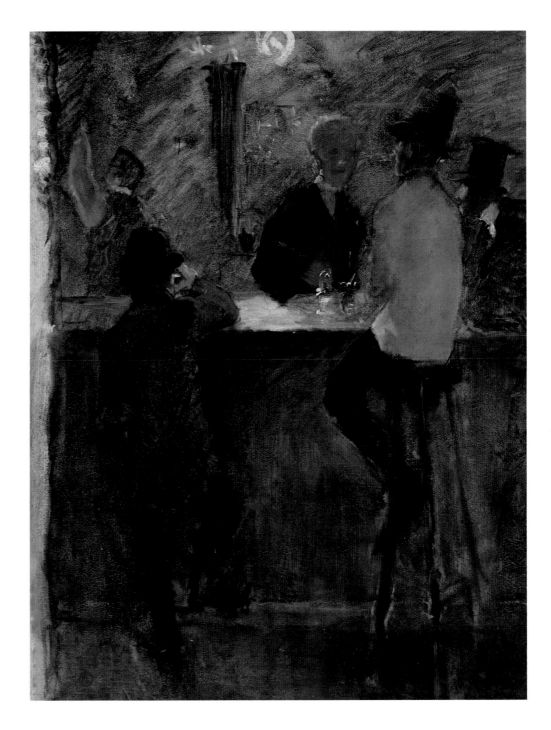

TWENTIETH CENTURY

GEORGES BRAQUE (1882–1963)

Braque's family moved from Argenteuil, where he was born, to Le Havre in 1890. He developed an early interest in art, working on his own and studying at the local Ecole des Beaux-Arts. He also apprenticed in the trade of his father, a house-painting contractor; many of the illusionistic tricks of simulating expensive materials learned at that time were used to good advantage in his later work. He moved to Paris in 1900, and after a year's military service, 1901–02, he devoted himself exclusively to art. He was associated from 1905 with the Fauves, and from 1908 he collaborated closely with Picasso in the creation of Cubism. After World War I, in which he was seriously wounded, he developed a style that retained elements of Synthetic Cubism but that was less severe and abstract. He worked within a narrower range of stylistic variation than Picasso during the post-war period, when his emphasis was on exquisitely fine-tuned harmonies of color, texture, and form that were fundamentally lyrical in expression. Printmaking and sculpture were also included in his later production.

44 *Still Life*, 1928

Oil and sand on canvas, 48.9 x 90.2 (19 ¼ x 35 ½)
Signed and dated, lower right: *G. Braque 28*
Acc. no. 83.11

Table-top still lifes of bold design and broad decorative effect predominate in Braque's production of the year 1928. Fruit was a common element in his work from the early '20s, and the stylized bunch of grapes set in a compote, as here, was a particularly distinctive motif.

REFERENCES: *Catalogue de l'oeuvre de Georges Braque, peintures 1928–1935* (Paris, 1962), no. 8 (illus.). Marco Valsecchi and Massimo Carrà, *L'opera completa di Braque, dalla scomposizione cubista al recupero dell'oggetto, 1908–1929* (Milan, 1971), no. 374 (illus.).

EXHIBITIONS: *Exhibition of Modern French Paintings*, Detroit Institute of Arts, May 22–June 30, 1931, no. 8 (illus.). *Art in Our Time*, Museum of Modern Art, New York, May 11–Oct. 31, 1939, no. 167. *Georges Braque*, Phillips Memorial Gallery, Washington, D.C., Dec. 1939–Jan. 1940, no. 34. *Georges Braque*, no. 56, pp. 111, (illus.), 113 (illus.): Cleveland Museum of Art, Jan. 26–March 13, 1949; Museum of Modern Art, New York, March 29–June 12, 1949. *French Paintings from the Collection of Mr. and Mrs. Paul Mellon*, Virginia Museum of Fine Arts, April 4, 1967–June 5, 1968.

COLLECTIONS: Mrs. Frank Crowninshield, New York. Mrs. Frederick G. Atkinson, Minneapolis. Mr. and Mrs. John Rood, Minneapolis (Mrs. Rood formerly Mrs. Atkinson). M. Knoedler & Co., New York, until 1960.

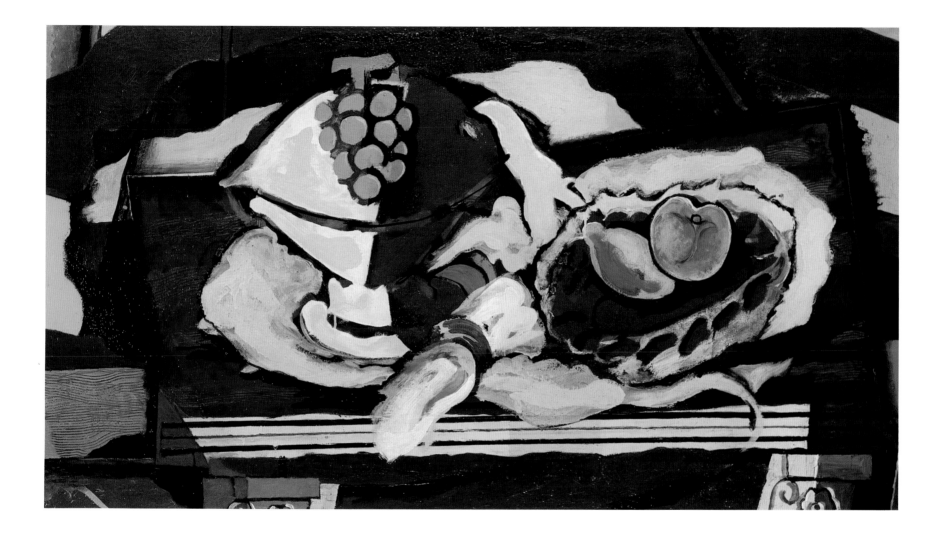

45 *The Yellow Bouquet*, 1952

Oil on canvas, 64.7 x 30.5 (25 ½ x 12)
Signed, lower right: *G. Braque*
Acc. no. 83.12

Braque's commission for a ceiling in the Louvre was a major preoccupation during 1952. He also executed at least nine flower paintings, mostly bouquets in vases, as in this painting; the flowers included daisies, dahlias, and sunflowers.

REFERENCES: *Frankfurter Illustrierte* (May 11, 1952) (shows painting unfinished in the artist's studio). *Verve* 7/27–28 (1952): 82 (illus.). *Art et Industrie* 25: 12 (illus.). *Catalogue de l'oeuvre de Georges Braque, Peintures 1948–1957* (Paris, 1959), no. 52 (illus.).

EXHIBITIONS: *Braque*, Galerie Maeght, Paris, June–July 1952, no. 23. *Braque*, Kunsthalle, Berne, 1953, no. 110. *29th Biennale*, Venice, 1958, no. 22. Palazzo Barberini, Rome, Dec. 1958. *The Aldrich Collection*, Virginia Museum of Fine Arts, Jan. 16–March 1, 1959, no. 4 (illus.). *The Aldrich Collection*, Atlanta Art Association Galleries, 1959. *The Aldrich Collection*, organized by the American Federation of Arts, Oct. 1960–April 1962, no. 5 (illus.): Philbrook Art Center, Tulsa; Dallas Museum of Fine Arts; The Municipal Gallery, Los Angeles; San Francisco Museum of Art; Seattle Art Museum; The Arts Club of Chicago; Michigan State University, East Lansing; Minneapolis Institute of Arts; The DeCordova and Dana Museum and Park, Lincoln, Massachusetts; The Albany Institute of History and Art; The Allentown Art Museum, Allentown, Pennsylvania; The Tucson Fine Arts Association; City Art Museum of St. Louis.

COLLECTIONS: Aimé Maeght, Paris. M. Daelemans, Brussels. Larry Aldrich Foundation, Inc., New York; sold Christie's, London, June 24, 1966, no. 59 (illus.).

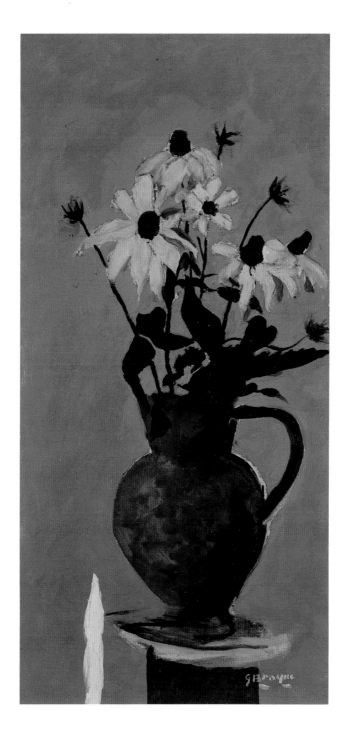

ANDRE DERAIN (1880–1954)

A prominent Fauve, by 1908 Derain had abandoned that movement under the influence of Cézanne, Cubism, and the study of the old masters. Following World War I his work became more naturalistic, classically organized, and restrained in color. In addition to paintings he produced illustrations for books; he was also active as a set and costume designer for the ballet.

46 *The Port of Douarnenez*, 1936

Oil on canvas, 50.8 x 60.3 (20 x 23³/₄)
Signed, lower right: *Derain*
Acc. no. 83.19

Derain frequented the Breton fishing port of Douarnenez in 1936, a year noteworthy also for his activity as a designer for the Ballets Russes de Monte-Carlo.

REFERENCES: Reginald Brill, *Modern Painting and its Roots in European Tradition* (London, 1946), pl. 17.

EXHIBITIONS: *André Derain*, Wildenstein & Co., London, 1957, no. 62. *French Paintings from the Collection of Mr. and Mrs. Paul Mellon*, Virginia Museum of Fine Arts, April 4, 1967–June 5, 1968.

COLLECTIONS: Alex Reid & Lefevre, London. Lord Hervey of Tasburgh; sold Sotheby's, London, June 23, 1965, no. 53 (illus.).

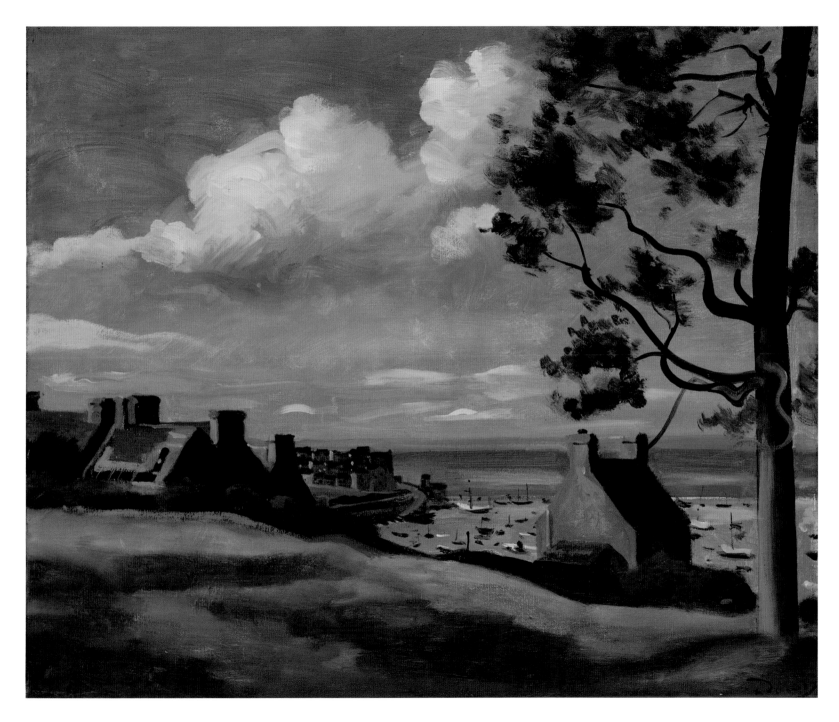

KEES VAN DONGEN (1877–1968)

Van Dongen, who was born in Holland, settled in Paris at the age of twenty. In 1906 he became closely associated with the Fauves, and in his later work he retained the intense, flat color characteristic of that movement. Another persistent element was a vein of whimsical irony, modish at times but, at its best, not without a telling mordancy. During the second half of his career he was a successful international society portraitist.

47 *Parisian Lady,* 1910

Oil on canvas, 61.9 x 50.8 (24⅜ x 20)
Signed, upper right: *Van Dongen*
Acc. no. 83.21

This is one of several Fauve-derived renderings of women wearing extravagant hats from the years 1910–11.

REFERENCES: Louis Chaumeil, *Van Dongen* (Geneva, 1967), p. 319, pl. 76.

EXHIBITIONS: *Les maîtres de l'art indépendant 1895–1937,* Petit Palais, Paris, June–Oct. 1937, no. 3; lent by the artist as *Parisienne* (*La Dame au Chien*). *Collectors' Choice,* Virginia Museum of Fine Arts, April 23–June 5, 1960. *French Paintings from the Collection of Mr. and Mrs. Paul Mellon,* Virginia Museum of Fine Arts, April 4, 1967–June 5, 1968.

COLLECTIONS: Marlborough Fine Art, Ltd., London, until 1957.

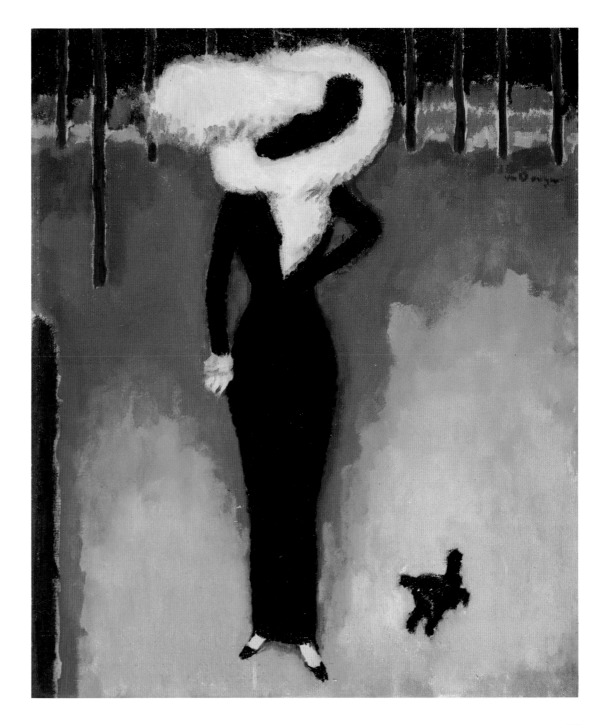

48 *Fancy Dog,* 1920

Oil on canvas, 17.8 x 22.8 (7 x 9)

Signed, upper right: *Van Dongen*

Inscribed on verso: *Chien de Luxe / et vie de chien quandmême appar-
tient à Jean-Marie van Dongen / VD*

Acc. no. 83.20

COLLECTIONS: Jean-Marie Van Dongen. O'Hana Gallery, London, until 1962.

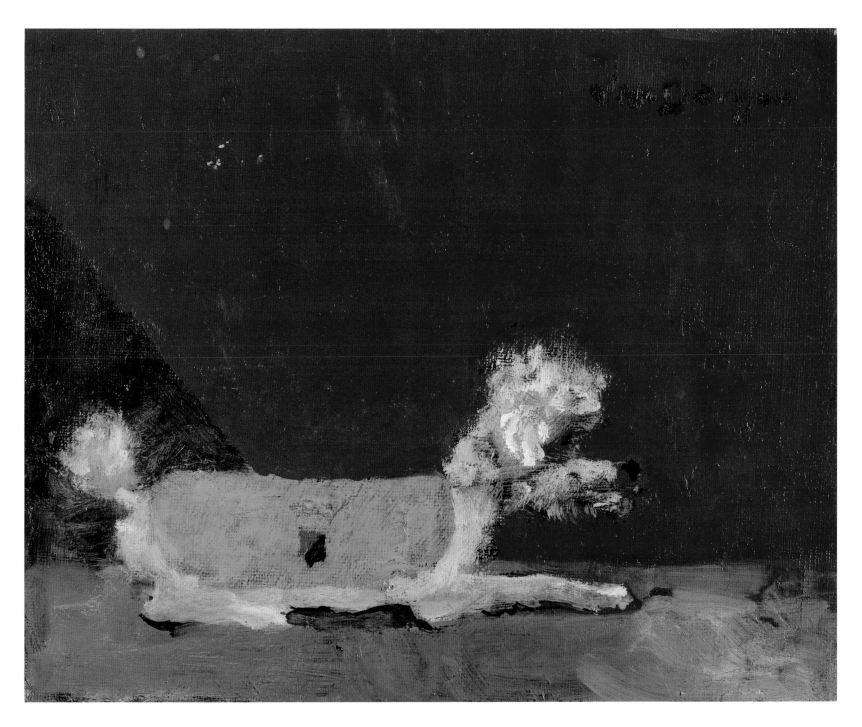

ROGER DE LA FRESNAYE (1885–1925)

La Fresnaye exhibited with the Cubists at the Salon d'Automne from 1910 to 1913. He was more in sympathy, however, with the work of Jacques Villon and the Section d'Or group than he was with the Cubism of Picasso and Braque. This is especially evident in his masterpiece, The Conquest of the Air *(Museum of Modern Art, New York), painted in the same year as the works below. La Fresnaye died at the age of 40 from an illness contracted during military service in World War I.*

49 *The Turpentine Bottle,* ca. 1913

Oil on canvas, 60 x 73 (23⁵/₈ x 28³/₄)
Not signed
Acc. no. 85.501

This work is from the same series of still lifes as *Still Life with Bottle, Pipe, and Pot of Tobacco* (catalogue no. 50) but is slightly earlier. A watercolor study is known (private collection, New York).[29]

REFERENCES: Waldemar George, "Roger de La Fresnaye," *L'Amour de L'Art,* 7th year, no. 10 (1926): 318 (illus.), 319. P. Chadourne, "Notes sur R. de La Fresnaye," *Cahiers d'Art* 3/8 (1928): 318 (illus.). R. Huyghe, *L'histoire de l'art contemporain, la peinture* (Paris, 1933), p. 250. E. Nebelthau, *Roger de La Fresnaye* (Paris, 1935), 18th illus. (no. illus. nos.). R. Cogniat and W. George, *Oeuvres complètes de Roger de La Fresnaye,* vol. 1 (Paris, 1950), pl. 13. B. Dorival, *Le XXᵉ Siècle* (Paris, 1957), illus. in color on cover and on p. 120. Germain Seligman, *Roger de La Fresnaye* (Greenwich, Connecticut, 1969), no. 170, p. 167 (illus.).

EXHIBITIONS: *Les créateurs du cubisme,* Galerie de la Gazette des Beaux-Arts, Paris, March–April 1935, no. 82. *Cubism and Abstract Art,* Museum of Modern Art, New York, 1936, no. 118, fig. 69. *Les maîtres de l'art indépendant 1895–1937,* Petit Palais, Paris, June–Oct. 1937, no. 8. *Le cubisme,* Musée d'Art Moderne, Paris, Jan.–April 1953, no. 132, p. xxxi (illus.). *Vier Eeuwen Stilleven in Frankrijk,* Museum Boymans, Rotterdam, 1954, no. 170, pl. 87. *La Fresnaye,* Galerie de l'Institut, Paris, 1962, no. 10 (illus.).

COLLECTIONS: de Mire, Paris. J. Bonjean, Paris. C. M. de Hauke, Paris. Hector Brame, Paris; until 1969.

[29] Seligman, *Roger de La Fresnaye,* no. 171 (see "References").

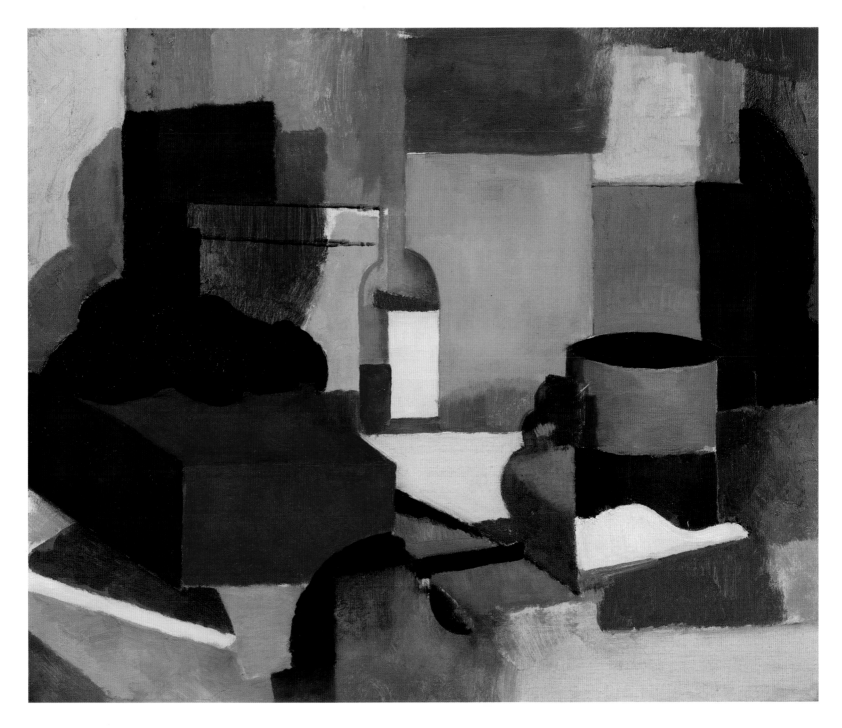

50 *Still Life with Bottle, Pipe, and Pot of Tobacco*, 1913–14

Oil on canvas, 73 x 92.1 (28³/₄ x 36¹/₄)
Not signed
Acc. no. 83.29

This painting is closely related to *Still Life with Bottle and Pipe* (collection of Hans R. Hahnloser, Berne).[30] A watercolor and charcoal study for it exists (private collection, Cannes.)[31]

REFERENCES: *Painting and Sculpture in the Museum of Modern Art*, ed. Alfred H. Barr, Jr. (New York, 1942), no. 348, p. 50 (illus.); 1948, no. 410, p. 94 (illus.). Germain Seligman, *Roger de La Fresnaye* (New York, 1945), no. 23, p. 40. Germain Seligman, *Roger de La Fresnaye* (Greenwich, Connecticut, 1969), no. 175, p. 168 (illus.). Alfred H. Barr, Jr., *Paintings and Sculpture in the Museum of Modern Art, 1929–1967* (New York, 1977), p. 557, p. 101 (illus.).

EXHIBITIONS: *Summer Exhibition*, Museum of Modern Art, New York, 1932. Mount Holyoke College, 1933. *Art in Progress*, Museum of Modern Art, New York, 1944.

COLLECTIONS: Arthur B. Davies; sold American Art Galleries, New York, 1929. Mrs. John D. Rockefeller, Jr., New York; donated in 1940 to Museum of Modern Art. Museum of Modern Art, New York. E. V. Thaw & Co., New York, until 1971.

[30] Seligman, *Roger de La Fresnaye*, no. 173 (see "References").
[31] Seligman, *Roger de La Fresnaye*, no. 174 (see "References").

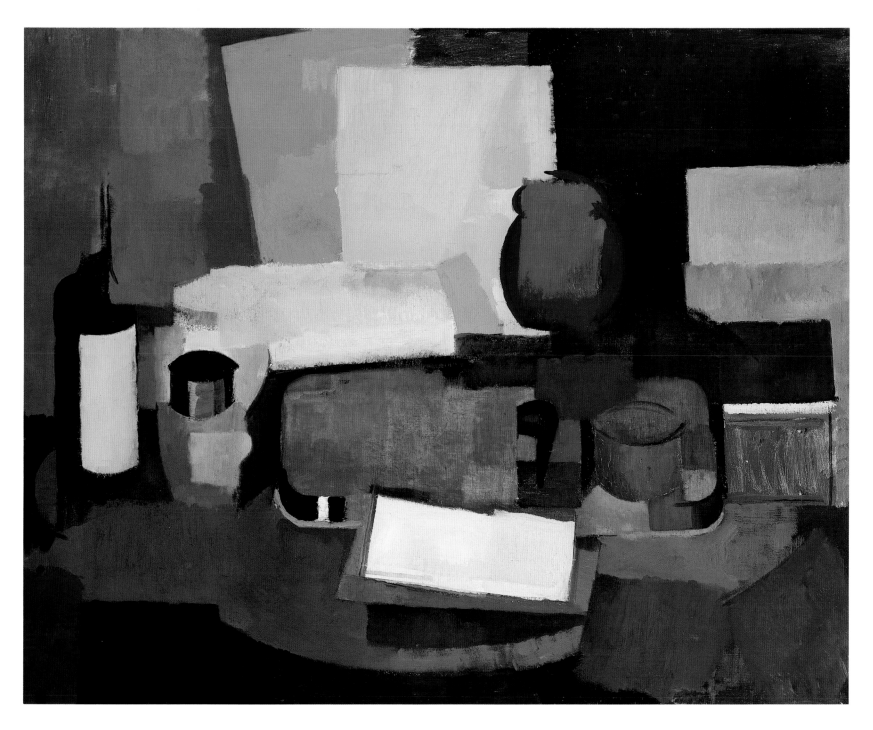

RENE MAGRITTE (1898–1967)

Brussels was Magritte's home from 1918, when his family settled there, until his death. He made occasional trips to England, Holland, and France, and spent three years, 1927–30, in Paris. His association with the Belgian Surrealist movement dates from the mid 1920s and with the French Surrealists from shortly thereafter. He was on close terms with the poets André Breton and especially Paul Eluard, one of whose works he illustrated. A significant feature distinguishing Magritte's work from that of many other Surrealists was his avoidance of the automatism advocated by Breton. Its goal was to liberate the subconscious, but Magritte consistently favored conscious, if not rational, control, and he aimed for poetic evocation through incongruous, startling juxtaposition and visual ambiguity.

51 *The Seducer*, 1950

Oil on canvas, 48.2 x 58.4 (19 x 23)
Signed, upper right: *Magritte*
Acc. no. 83.34

This painting has been assigned to the sixth category of a comprehensive classification of Magritte's works: the double image as a form of visual pun.[32]

REFERENCES: Suzi Gablik, *Magritte* (Greenwich, Connecticut, 1970), pp. 108, 125, fig. 90.
COLLECTIONS: Alexander Iolas, New York; sold Sotheby's, London, April 30, 1969, no. 99 (illus.).

[32] Gablik, *Magritte*, p. 125 (see "References").

ALBERT MARQUET (1875–1947)

Marquet was born in Bordeaux but moved to Paris at an early age. He worked in the studio of Gustave Moreau with Matisse and Rouault and was a member of the Fauves in 1905. Soon after he developed a style of supple linear structure and muted color harmony that changed little over his career. He was preeminently a painter of Paris and Marseilles, although he traveled widely.

52 *Still Life,* ca. 1900

Oil on canvas, 26.6 x 34.9 (10½ x 13¾)
Signed, lower left: *Marquet*
Acc. no. 83.35

Among Marquet's pre-Fauve works of about 1900 are a number of still lifes.

EXHIBITIONS: *French Paintings from the Collection of Mr. and Mrs. Paul Mellon,* Virginia Museum of Fine Arts, April 4, 1967–June 5, 1968.

COLLECTIONS: Private collection, Paris. Robert F. Woolworth, New York. M. Knoedler & Co., New York, until 1965.

ALBERT MARQUET

53 *Ebb Tide at Pyla,* 1935

Oil on canvas, 64.7 x 80.6 (25 1/2 x 31 3/4)
Signed, lower right: *Marquet*
Acc. no. 85.502

Pyla (Pyla-sur-Mer), part of a popular resort complex forty miles west of Bordeaux, is a seaside extension of the town of Arachon, which is situated at the mouth of the large lagoon, or *bassin*, of that name. Marquet frequented this area in 1935 and painted numerous seascapes at Pyla.

EXHIBITIONS: *Exposition Albert Marquet*, Musée Toulouse-Lautrec, Albi, July 6–Sept. 25, 1957, no. 52 (illus., as *Fin d'été au Pyla*). *Albert Marquet, peintre français*, 1964, no. 35 (illus.): Museum of Fine Arts, Montreal; Musée des Beaux Arts, Quebec; National Gallery, Ottawa. *Marquet*, Knoedler Gallery, New York, May 6–29, 1964, no. 40 (illus.; detail on cover). *French Paintings from the Collection of Mr. and Mrs. Paul Mellon*, Virginia Museum of Fine Arts, April 4, 1967–June 5, 1968.

COLLECTIONS: M^me Marcelle Marquet, Paris. M. Knoedler & Co., New York, until 1964.

54 *The Louvre*, 1936

Oil on canvas, 64.7 x 80.6 (25 ½ x 31 ¾)

Signed, lower left: *Marquet.* Inscribed, on back of canvas: *19 I / Le LOUVRE / MM*

Acc. no. 83.36

Marquet painted aerial views of Paris, Venice, Algiers, and many other sites from his early maturity on.

EXHIBITIONS: *Exposition Albert Marquet*, Musée Toulouse-Lautrec, Albi, July 6–Sept. 25, 1957, no. 53 (illus.). *Albert Marquet*, Rijksakademie van Beeldende Kunsten, Amsterdam, 1962, no. 37. *Albert Marquet, peintre français*, 1964, no. 45 (illus.): Museum of Fine Arts, Montreal; Musée des Beaux Arts, Quebec; National Gallery, Ottawa. *Marquet*, Knoedler Gallery, New York, May 6–29, 1964, no. 42. *French Paintings from the Collection of Mr. and Mrs. Paul Mellon*, Virginia Museum of Fine Arts, April 4, 1967–June 5, 1968.

COLLECTIONS: M^me Marcelle Marquet, Paris. M. Knoedler & Co., New York, until 1964.

HENRI MATISSE (1869–1954)

Matisse was briefly a pupil of Bouguereau and, for a longer time, 1892–97, of Gustave Moreau. In the late 1890s he experimented with Impressionism and evinced a certain interest in the work of the Nabis. The true nature of his inclinations—a deep and abiding preoccupation with the expressive potential of flat pattern, arabesque, and, above all, color—came to the fore in his association with the Fauve movement, of which he was the acknowledged leader. From the First World War on his time was increasingly spent on the French Riviera, and his activity was almost exclusively confined there during the last decades of his life. Though bed-ridden toward the end, he continued to produce works of great significance. Among the most notable were his decorations for the Chapel of the Dominican Nuns at Vence completed in 1951.

55 Interior (*La Fenêtre Fermée*), 1918–19

Oil on canvas, 54 x 44.4 (21¼ x 17½)
Signed, lower left: *Henri Matisse*
Acc. no. 83.37

A photograph of this painting made by the Bernheim-Jeune Gallery, Paris, is dated March 1919.[33]

Matisse wintered in Nice perhaps as early as 1916–17. Until 1918 he stayed at the Hôtel Beau-Rivage in a room overlooking the Promenade des Anglais along the seafront. In that year the hotel was requisitioned by the American Army, and he moved to the Hôtel de la Méditerranée, where for three seasons he occupied a room with a similar exposure. That room is the subject of the present painting. An almost identical view but with the French doors open is the subject of a painting of ca. 1919 (Musée des Beaux-Arts, Besançon).[34]

COLLECTIONS: Probably Galerie Bernheim-Jeune, Paris. Lefevre Gallery, London. Knoedler Gallery, New York, by 1928. Stephen C. Clark, New York. Durand-Ruel, Inc., New York, until 1948.

[33] This information was kindly provided by Jack Cowart, Curator of 20th Century Art, National Gallery, Washington, D.C. Mr. Cowart also made a number of corrections and additions to this entry.

[34] M. Carrà and Xavier Deryng, *Tout l'oeuvre peint de Matisse, 1904–1928* (Paris, 1982), no. 291 (illus.).

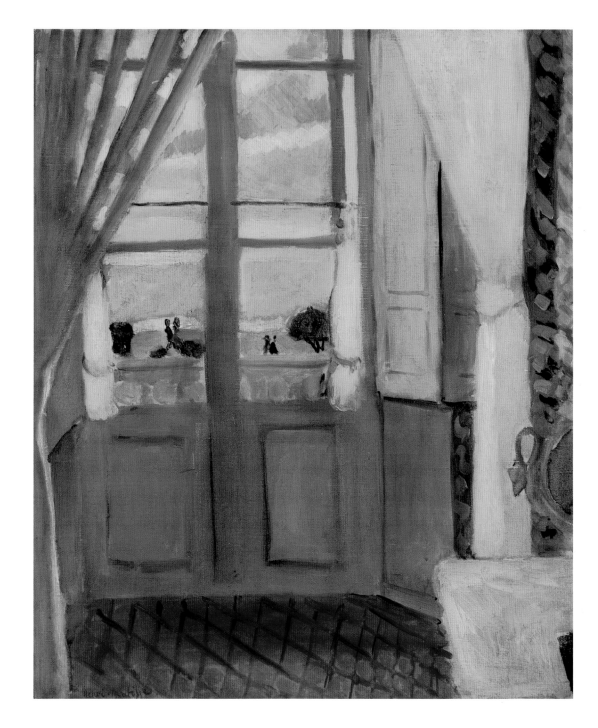

PABLO PICASSO (1881–1973)

Picasso was born in Málaga. In 1895 he moved with his family to Barcelona, where his initial training as an artist took place. He first visited Paris in 1900 and traveled repeatedly between that city and Barcelona over the next four years. He finally settled in Paris in 1904, maintaining a studio there until 1948. His early work is characterized by wide-ranging stylistic variation and the influences of a number of late nineteenth-century French artists, especially Toulouse-Lautrec. His Blue Period (ca. 1901–04), which is characterized by melancholy mood and alienated and despairing personages, was followed by the more positive, gayer, and even lyrical Rose Period. From 1907 to World War I he created, in collaboration with Braque, that most important of twentieth-century styles, Cubism. His development after that period took many directions, and, though less so after 1950, he remained an important force in contemporary art until his death.

56 *Jester on Horseback*, 1905

Oil on composition board, 100 x 69.2 (39⅜ x 27¼)
Signed, lower left: *Picasso*
Acc. no. 84.2

Frequently but incorrectly dated 1904, this work clearly belongs to the circus subjects (saltimbanques, harlequins, clowns, etc.) executed during the first half of 1905. The title almost universally applied, *Harlequin on Horseback*, is also incorrect. Instead of the cocked hat and lozenge-patterned suit worn by Harlequin, this figure wears the ruffled collar and peaked hat with scalloped brim and adorned with bells that are proper to the fool or jester. Figures so garbed are almost as common in Picasso's work of 1905 as are harlequins. A watercolor study for this work is known.[35]

On the reverse are brush drawings of a male profile and a female torso (fig. 5). In Picasso's etching *La Toilette de la Mère*,[36] the principal figures are related closely enough to these drawings to suggest that they might have served as studies.

REFERENCES: Thieme-Becker, *Allgemeines Lexikon der bildenden Künstler*, vol. 26 (Leipzig, 1932), p. 577. André Level, *Picasso* (Paris, 1928), pl. 10. Jaime Sabartés and Wilhelm Boeck, *Pablo Picasso* (Paris, 1955), p. 459, no. 25. Denys Sutton, *Picasso, peintures époques bleue et rose* (Paris, 1955), pl. VII. Christian Zervos, *Pablo Picasso*, vol. 1, 3d ed. (Paris, 1957), no. 243 (illus.). Jean Cassou, *Picasso* (Paris, 1958), p. 26 (illus.). Raymond Cogniat, *Picasso, Figures* (Lausanne, 1959), p. 17 (illus.). Pierre Daix, *Picasso 1900–1906* (Neuchâtel, 1966), no. XII.24, pp. 81 (color illus.), 264 (illus.). Alberto Moravia and Paolo Lecaldano, *L'opera completa di Picasso, blu e rosa* (Milan, 1968), no. 196, pl. XXXVIII (London, 1971; New York, 1972). John Baskett, *The Horse in Art* (Boston, 1980), p. 151 (illus.). Josep Pälau i Fabre, *Picasso, Life and Work of the Early Years, 1881–1907* (Oxford, 1981), no. 1065 (illus.).

EXHIBITIONS: *Exposition Picasso*, Galerie Georges Petit, Paris, June 16–July 30, 1932, no. 18. *Picasso*, Kunsthaus, Zurich, Sept. 11–Nov. 13, 1932, no. 275. *De Cézanne à Picasso, Maîtres de l'aquarelle au XXᵉ siècle*, Musée Jenisch, Vevey, July 7–Sept. 23, 1962, no. 184 (illus.). *French Paintings from the Collections of Mr. and Mrs. Paul Mellon and Mrs. Mellon Bruce*, National Gallery of Art, Washington, D.C., March 17–May 1, 1966, no. 195 (illus.). *Aspects of Twentieth Century Art: Picasso and Cubism*, National Gallery of Art, Washington, D.C., June 1, 1978 (illus.). *Picasso: The Saltimbanques*, National Gallery of Art, Washington, D.C., Dec. 14, 1980–March 15, 1981, no. 52 (illus.).

COLLECTIONS: M. Level, Paris. H. L. Mermod, Lausanne. M. Knoedler & Co., New York, until 1963.

[36] See Bernhard Geiser, *Picasso, peintre-graveur* (Berne, 1933), no. 15/b.

5. Brush drawings on reverse side of *Jester on Horseback*,
1905 (catalogue no. 56).

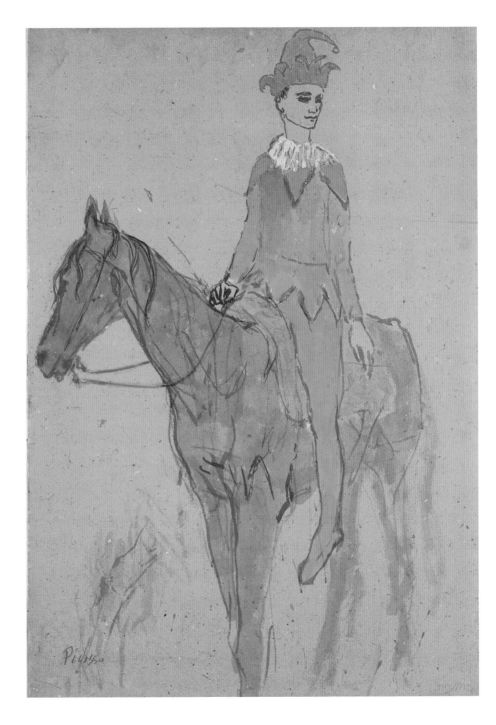

57 *The Chinese Chest of Drawers*, 1953

Oil on panel, 147.3 x 114.3 (58 x 45)
Signed, upper right: *Picasso*
Acc. no. 83.43

This work has been dated to March 22, 1953.[37]

REFERENCES: Christian Zervos, *Pablo Picasso*, vol. 15 (Paris, 1965), no. 249 (illus.).
COLLECTIONS: Galerie Louise Leiris, Paris. Saidenberg Gallery, New York. Parke-Bernet, New York, Oct. 26, 1967, no. 68 (illus.); not sold (purchased after sale from private owner).

[37] Zervos, *Pablo Picasso*, vol. 15, no. 249 (see "References").

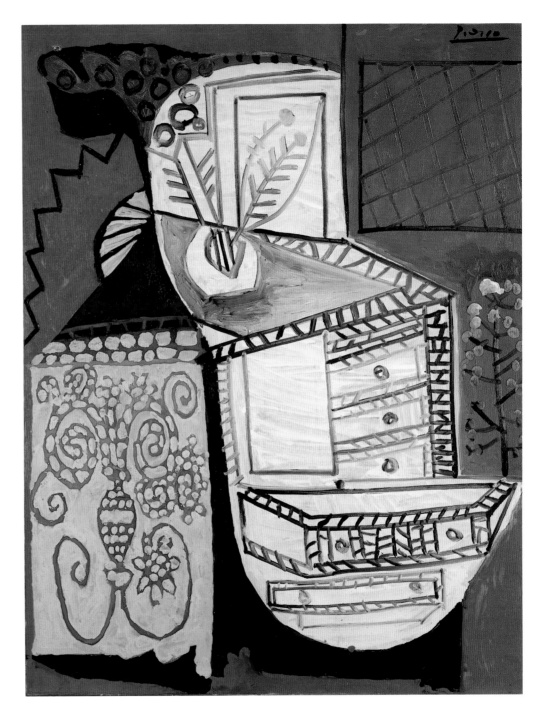

58 *Pigeon on a Perch,* 1960

Oil on canvas, 44.4 x 54 (17$\frac{1}{2}$ x 21$\frac{1}{4}$)
Signed, upper right: *Picasso*
Acc. no. 83.42

Pigeon on a Perch, along with three other works on the same theme, has been dated to the five-day period March 16–20, 1960.[38]

REFERENCES: Christian Zervos, *Pablo Picasso*, vol. 19 (Paris, 1968), no. 221 (illus.).
COLLECTIONS: Paul Rosenberg & Co., New York, until 1961.

[38] Zervos, *Pablo Picasso*, vol. 19, nos. 218–21 (see "References").

HENRI ROUSSEAU, Le Douanier (1844–1910)

Like most naive painters Rousseau was self-taught, although as a youth he had had drawing lessons at the lycée in his native Laval. It is now known that his supposed sojourn in tropical Mexico while serving in the French Army during the 1860s was a myth to which he contributed a little and the poet Apollinaire much. After five years in the army, all spent in France, Rousseau secured a post in the Parisian Octroi (municipal customs or toll office). He probably had been painting for at least a decade prior to his retirement in 1893, and he exhibited regularly at the Salon des Indépendants from 1886 until his death. He was widely known and admired, and during the first decade of the twentieth century was lionized by painters and poets of the avant-garde. His work had a strong and pervasive influence on many subsequent painters.

59 *Tropical Landscape—An American Indian Struggling with a Gorilla,* 1910

Oil on canvas, 113.6 x 162.5 (44³/₄ x 64)
Signed and dated, lower right: *Henri Rousseau / 1910*
Acc. no. 84.3

This is one of about ten tropical forest paintings done during the eight months preceding the artist's death on September 2, 1910. Most are of very much the same size, the major exception being the considerably larger *The Dream* (1.04 by 2.98 m.), which was shown at the Salon des Indépendants in the spring of 1910. An advertising vignette representing two Indians hunting bison has been cited as the source for the Indian's costume in the Mellon painting.[39] Of the myriad animal and ethnic types represented in the artist's oeuvre, both an American Indian and a gorilla appear only in this painting.

REFERENCES: Alexander Watt, "Notes from Paris," *Apollo* (Feb. 1936): 107–08 (illus.). R. H. Wilenski, *Modern French Painters* (London, 1940), p. 206. Daniel Catton Rich, *Henri Rousseau* (New York, 1942), p. 67 (illus.). *Pictures on Exhibit* 5/4 (Jan. 1942): 9 (illus.). Douglas Cooper, "Henri Rousseau, Artiste-peintre," *Burlington Magazine* 85 (July 1944): 164. Jean Bouret, *Henri Rousseau* (Greenwich, Conn., 1961), fig. 229. Dora Vallier, *Henri Rousseau* (New York, 1961), pl. 157. *Time*, Nov. 22, 1963, p. 42 (illus.). Dora Vallier, *L'opera completa di Rousseau il Doganiere* (Milan, 1969), p. 112, no. 247 (illus.); French editions, Paris, 1970 and 1982. Carolyn Keay, *Henri Rousseau* (London, 1976), no. 78 (illus.). Yann le Pichon, *Le monde du douanier Rousseau* (Paris, 1981), pp. 170–71 (illus.); English ed., Oxford, 1982. Henry Certigny, *Le douanier Rousseau en son temps*, vol. 2 (Tokyo, 1984), no. 320, pp. 694, 695 (illus.). Cornelia von Stabenow, *Henri Rousseau, Die Dschungelbilder* (Munich, 1984), p. 21, illus. on cover and pl. 24. Grace Glueck, "Putting Rousseau in Perspective," *The New York Times Magazine*, Feb. 17, 1985, p. 49 (illus.). Dan Hofstadter, "The Fantasy of Henri Rousseau," *Arts & Antiques* (April 1985), p. 43 (illus., detail).

EXHIBITIONS: *Paintings and Prints by the Masters of Post-Impressionism*, St. Louis Art Museum, April 4–26, 1931, no. 28. *Literature and Poetry in Painting Since 1850*, Wadsworth Atheneum, Hartford, Jan. 24–Feb. 14, 1933, no. 63. *Five Centuries of European Painting*, Los Angeles County Museum of Art, Nov. 25–Dec. 31, 1933, no. 52. *Peintres instinctifs*, Galerie des Beaux-Arts, Paris, Dec. 1935–Jan. 1936, no. 120. *Les maîtres populaires de la réalité* (organized by the Musée de Grenoble), Kunsthaus, Zurich, 1937, no. 16. *Henri Rousseau*, 1942, pp. 64, 67, 69 (illus.): Art Institute of Chicago, Jan.–Feb.; Museum of Modern Art, New York, March–May; Institute of Modern Art, Boston, Oct.–Nov. *Paintings by Henri Rousseau*, Carnegie Institute, Pittsburgh, Dec. 4–27, 1942, no. 4. *Eight Masterpieces of Painting*, Portland (Oregon) Art Museum, Dec. 1944, no. 8 (illus.). *French Paintings from the Collections of Mr. and Mrs. Paul Mellon and Mrs. Mellon Bruce*, National Gallery of Art, Washington, D.C., March 17–May 1, 1966, no. 117 (illus.). *Le douanier Rousseau*, no. 55; American ed., no. 56 (illus.): Galeries Nationales du Grand Palais, Paris, Sept. 14, 1984–Jan. 7, 1985; Museum of Modern Art, New York, Feb. 5–June 4, 1985 (exhibited only in New York).

COLLECTIONS: Tetzen Lund, Copenhagen. Leigh Block, Chicago. Wildenstein & Co., New York, until 1959.

[39] Pichon, *Le monde du douanier Rousseau*, p. 171, illus. (see "References").
F85-148/0 Fr. Paintings (p. 132) gal. 50

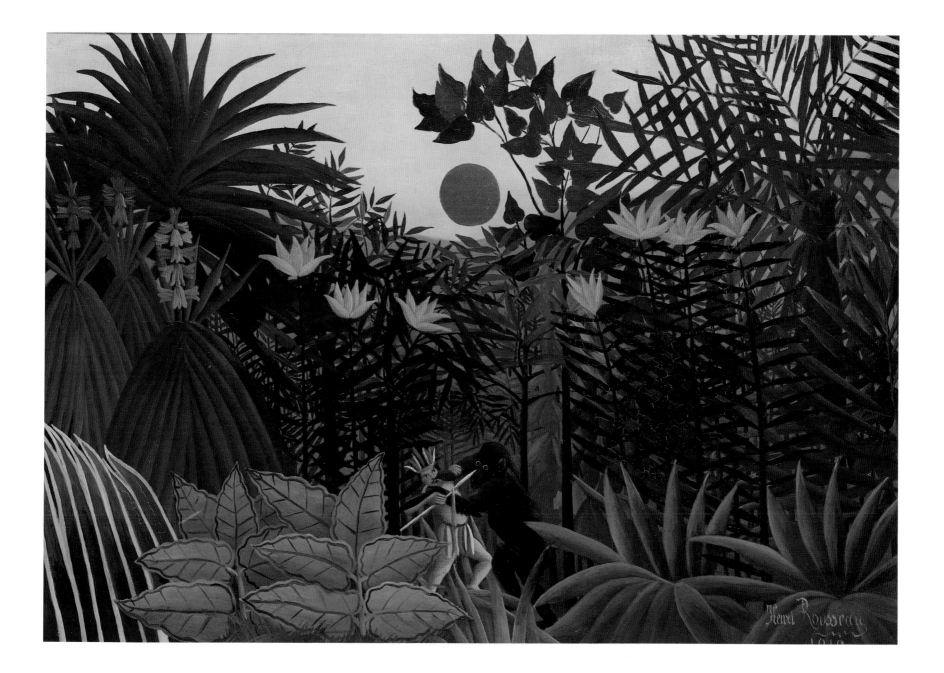

MAURICE UTRILLO (1883–1955)

Utrillo, the illegitimate son of the artist Suzanne Valadon (1865 or 1867–1938), was born in Montmartre, the section of Paris that provided the subject matter for much of his later work. Despite the chronic alcoholism with which he was afflicted from childhood, his output was enormous. He had a number of successful exhibitions during his lifetime, some jointly with his mother.

60 *Street in Sannois,* ca. 1911

Oil on canvas, 54.5 x 74.3 (21 ½ x 29 ¼)
Signed, lower right: *Maurice. Utrillo. v.*
Acc. no. 83.55

This work can be related to a number of street scenes in Sannois (Val d'Oise), a suburb of Paris.[40]

REFERENCES: O. Ocvirk, R. Bone, R. Stinson and P. Wigg, *Art Fundamentals, Theory and Practice,* 5th ed. (Dubuque, Iowa, 1985), p. 132, pl. 66.

EXHIBITIONS: *French Paintings from the Collections of Mr. and Mrs. Paul Mellon and Mrs. Mellon Bruce,* National Gallery of Art, Washington, D.C., March 17–May 1, 1966, no. 202 (illus.).

COLLECTIONS: Louis Libaude, Paris; the nephew of the late Louis Libaude is not certain that his uncle owned this painting, according to information kindly transmitted by M. Gilbert Pétridès, letter of Feb. 13, 1985. M. Knoedler & Co., New York, until 1948.

[40] See Paul Pétridès, *L'oeuvre complet de Maurice Utrillo,* vol. 1 (Paris, 1966), nos. 208–10 (all dated ca. 1910), nos. 262–68, 270 (all ca. 1911); vol. 5 (*supplément;* Paris, 1974), nos. 2512–15 (all ca. 1911–12). The Mellon painting is not included in Pétridès work but is to appear in a supplementary volume.

125

61 *The Barracks at Montmartre*, 1940

Oil on board, 17.8 x 23.2 (7 x 9¹/₈)
Signed and dated, lower right: *Maurice, Utrillo, / ,1940*
Acc. no. 83.56

This work is very close in composition to a gouache, signed and dated *Noël 1939*.[41]

COLLECTIONS: Wildenstein & Co., New York, until 1959.

[41] See Paul Pétridès, *L'oeuvre complet de Maurice Utrillo*, vol. 4 (Paris, 1966), no. AG465. The Mellon painting is not catalogued by Pétridès but is to be included in a supplementary volume.

FELIX VALLOTTON (1865–1925)

A naturalized French citizen, Vallotton was born in Switzerland. He spent much of his early career in Paris, where he attended the Académie Julian and the Ecole des Beaux-Arts. He was associated with the Nabis in the 1890s and exhibited with them; he also showed at the Salon des Indépendants in 1891 and at the first Salon d'Automne in 1903. Vallotton was also an illustrator of note and an art critic.

62 *The Green Room,* 1904

Oil on board, 61.5 x 63.5 (24¼ x 25)
Signed and dated, lower left: *F VALLOTTON . 04*
Acc. no. 83.57

The subject may be a room in the artist's apartment on the rue des Belles Feuilles in the 16th arrondissement, Paris. His work of 1904 includes a series of such interiors. The painting reveals Vallotton's Nabi affinities in its simplification of spatial structure and restrained refinement of color.

EXHIBITIONS: *Félix Vallotton*, Maison de la Pensée Française, Paris, 1955, no. 21.
COLLECTIONS: Jacques Rodrigues-Henriques (the artist's stepson), Paris. Jacques Laroche, Paris. Mrs. Walter Feilchenfeldt, Zurich, until 1966.

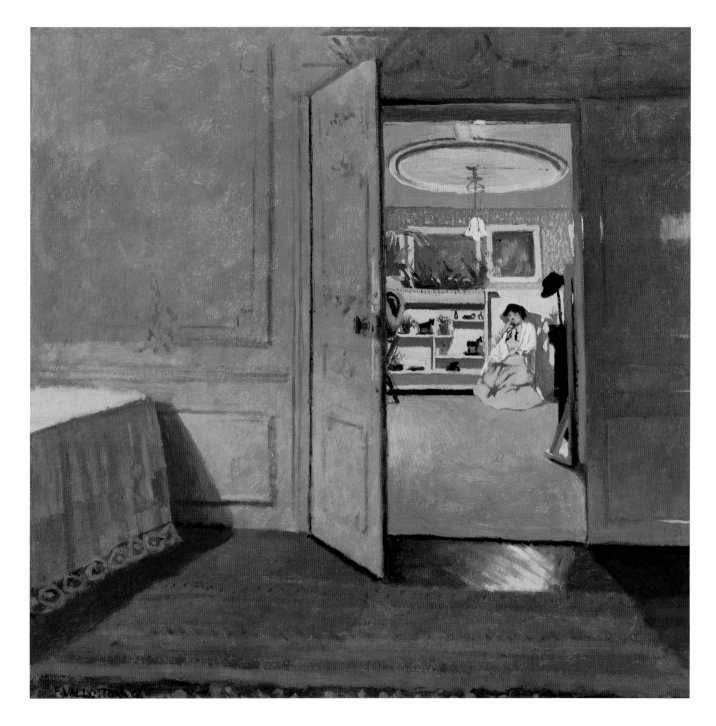

Born Gaston Duchamp, Villon was the brother of artists Raymond Duchamp-Villon, Marcel Duchamp, and Suzanne Duchamp. He adopted the name Jacques Villon when he abandoned law for art. He was active over a long period as a newspaper caricaturist and was a printmaker of great technical skill and talent. His interest in abstract art dates from about 1911–12 when, under the influence of Cubism and Orphism, he organized the group known as the Section d'Or (Golden Section), which focused on the mathematical basis of proportions. His work was dominated by such considerations for the remainder of his career.

63 *The Three Orders: The Castle, The Church, The Land,* 1944

Oil on canvas, 100 x 72.5 (39³/₈ x 28³/₄)

Signed, lower left: *Jacques Villon*; inscribed and signed on back of canvas: *Les 3 ordres / Le Chateau / L'Eglise / La Campagne / Jacques Villon / 44*

Acc. no. 85.503

This work is based on an etching of the same title made in 1939–40 while Villon resided in Beaugency, a town on the Loire River. The dominant motif is Beaugency's Romanesque church, and the title refers to the three orders of pre-Revolutionary France: the nobility, the clergy, and the commoners. The popularity of this painting and a related oil sketch has been explained in the following terms: "Villon's sense of order and discipline, combined with blazing color and a subtle evocation of eternal values and traditional beliefs, have an enduring appeal that made particular impact when the paintings were exhibited in Paris in 1944 and again in New York in 1949."[42]

REFERENCES: Paul Eluard, *Jacques Villon ou l'art glorieux* (Paris, 1948), p. 23. *Time*, May 16, 1949, p. 78 (illus.). Thomas B. Hess, "Villon, Feininger: Refining Cubism," *Art News* (Nov. 1949): 26 (illus). "The Cube Root," *Art Digest* (Jan. 1, 1950): 9 (illus.). Jacques Lassaigne, *Jacques Villon* (Paris, 1950), p. 11. René de Solier, "Le destin des formes," *Arts* (Paris; July 31, 1953). James Fitzsimmons, "Art," *Arts and Architecture* (Sept. 1953): 33. Jerome Mellquist, "Jacques Villon," *L'Oeil* (Feb.

15, 1955): 11 (illus.). Dora Vallier, "Intelligence de Jacques Villon," *Cahiers d'Art* 30 (1955): 101 (illus.). Dora Vallier, *Jacques Villon: Oeuvres de 1897 à 1956* (Paris, 1957), p. 77 (reprint of 1955 article; see preceding entry). Yvon Hecht, "Un grand maître normand, Jacques Villon ou la gloire tardive," *Presence Normande* (Rouen, Feb. 1956): 27 (illus.). *Jacques Villon*, ed. Daniel Robbins (Cambridge, Massachusetts, 1976), pp. 151–52, fig. 130a.

EXHIBITIONS: *Jacques Villon*, Galerie Louis Carré, Paris, Dec. 12–31, 1944. *Villon*, Louis Carré Gallery, New York, April 26–May 14, 1949, no. 9. *Jacques Villon—Lyonel Feininger*, no. 19 (illus. p. 20): Institute of Contemporary Art, Boston, Oct. 7–Nov. 20, 1949; Phillips Gallery, Washington, D.C., Dec. 11, 1949–Jan. 10, 1950; Delaware Art Center, Wilmington, March 6–26, 1950. 25th Venice Biennale, June 8–Oct. 15, 1950, no. 12, p. 207. *Jacques Villon*, Musée National d'Art Moderne, Paris, Feb. 5–March 25, 1951, no. 60. *Jacques Villon—Louis Moilliet*, Kunsthalle, Berne, May 5–June 3, 1951, no. 34 (illus.). *Exposition Jacques Villon*, Musée Toulouse-Lautrec, Albi, April 3–30, 1955, no. 26. 28th Venice Biennale, June 19–Oct. 21, 1956, no. 86, p. 381. *Salon d'Automne*, "Hommage à Jacques Villon," Grand Palais des Champs-Elysees, Paris, Nov. 2–Dec. 1, 1957, no. 31. *Paysages de France de l'Impressionnisme à nos jours*, Musée des Beaux-Arts, Rouen, July 5–Sept. 21, 1958, no. 190, pl. XXXI. *Eglises et cathedrales, peintures du XVᵉ au XXᵉ Siècle*, Chambre de Commerce, Chartres, May 4–June 8, 1960. *Cent tableaux de Jacques Villon*, Galerie Charpentier, Paris, April 27–June 22, 1961, no. 54 (illus.). *Kunst von 1900 bis heute*, Museum des 20. Jahrhunderts, Vienna, Sept. 21–Nov. 4, 1962, no. 192 (illus.). *Jacques Villon*, Kunsthaus, Zurich, Feb. 9–March 17, 1963, no. 44, pl. 8. *French Paintings from the Collection of Mr. and Mrs. Paul Mellon*, Virginia Museum of Fine Arts, April 4, 1967–June 5, 1968.

COLLECTIONS: Louis Carré. M. Knoedler & Co., until 1966.

[42] *Villon*, ed. Robbins, p. 151 (see "References").

64 *Horseback Riding, Chantilly*, 1950

Oil on canvas, 50.2 x 144.8 (19³/4 x 57)
Signed and dated, lower left: *Jacques Villon 50*
Acc. no. 83.58

In 1950 Villon won the grand prize at the Carnegie International exhibition in Pittsburgh for a work titled *The Large Horse-Drawn Reaper*. The present painting is related to the prize-winning work in its similar preoccupation with the expression of "the synthesis of movement by means of continuity," to quote a statement of the artist.[43]

REFERENCES: Jean Bouret, "Jacques Villon au Musée d'Art Moderne," *Beaux-Arts, Journal des Arts* (Feb. 9, 1951): 1 (illus.).

EXHIBITIONS: *Jacques Villon*, Musée National d'Art Moderne, Paris, Feb. 5–March 25, 1951, no. 85. *The School of Paris at Mid-Century. A Selection of Modern Paintings from the Collection of Mr. and Mrs. Charles Zadok*, The Arts Club of Chicago, May 1–June 6, 1952, no. 42. *French Paintings from the Collection of Mr. and Mrs. Paul Mellon*, Virginia Museum of Fine Arts, April 4, 1967–June 5, 1968.

COLLECTIONS: Galerie Louis Carré, Paris. Mr. and Mrs. Charles Zadok, New York; sold Sotheby's, London, June 22, 1965, no. 27 (illus.).

[43] Dora Vallier, *Jacques Villon: Oeuvres de 1897 à 1956* (Paris, 1957), p. 77.

EDOUARD VUILLARD (1868–1940)

In 1892 Vuillard was a founding member of the Nabis group along with Paul Sérusier, Maurice Denis, Pierre Bonnard, Félix Vallotton, and K.-X. Roussel. By the first years of the twentieth century he had largely abandoned that Symbolist-inclined style. His later work retained a certain amount of the flat patterning characteristic of the Nabis but showed a far greater concern for descriptive and representational plausibility. During his early years he did scene designs for the avant-garde theatre, and he was also active as a lithographer.

65 *Interior with a Man Reading,* ca. 1898

Oil and gouache on paper mounted on canvas, 36.9 x 58.1 ($14^{1}/_{2}$ x $22^{7}/_{8}$)

Signed, lower left: *E. Vuillard*

Acc. no. 83.59

EXHIBITIONS: *French Paintings from the Collections of Mr. and Mrs. Paul Mellon and Mrs. Mellon Bruce,* National Gallery of Art, Washington, D.C., March 17–May 1, 1966, no. 188 (illus.).

COLLECTIONS: Paul Rosenberg & Co., New York, until 1955.

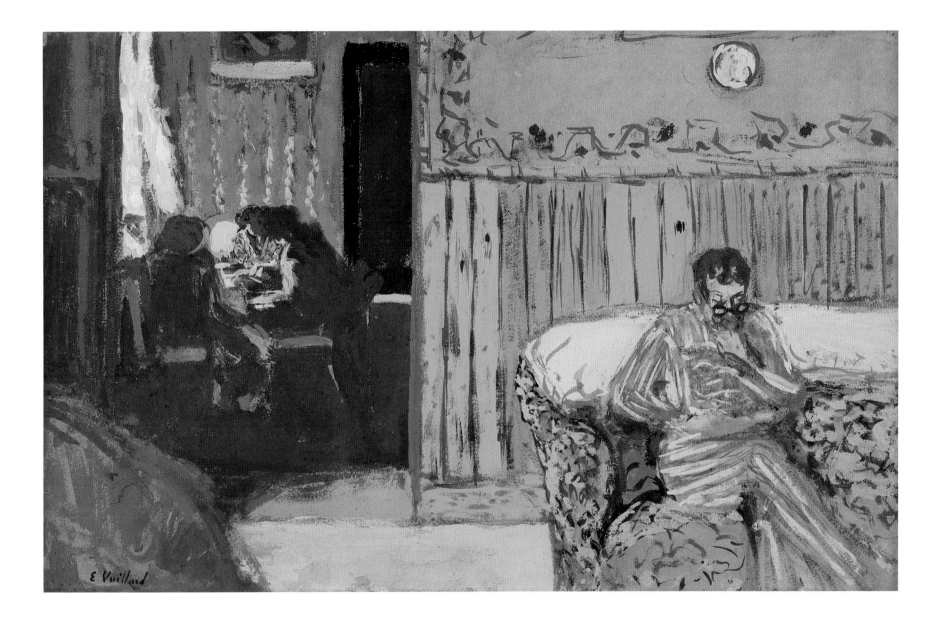

135

66 *Vase of Flowers,* ca. 1900

Oil and gouache on cardboard, 62 x 60 (24³/₈ x 23⁵/₈)
Signed, lower right: *E. Vuillard*
Acc. no. 85.504

In style as well as format and size, this work can be related to another interior by Vuillard (private collection, New York).[44] It is even closer in handling, though very different in subject and mood, to *At the Opera* of ca. 1900 (private collection, London).[45]

COLLECTIONS: Galerie Bernheim-Jeune, Paris. Galerie Schmit, Paris, until 1969.

[44] This related work was included in the exhibition *Edouard Vuillard, K.-X. Roussel,* no. 115 (illus.). Haus der Kunst, Munich, March 16–May 12, 1968; Orangerie des Tuileries, Paris, May 28–September 16, 1968.

[45] Illustrated in John Russell, *Edouard Vuillard, 1868–1940* (London, 1971), pl. 9.

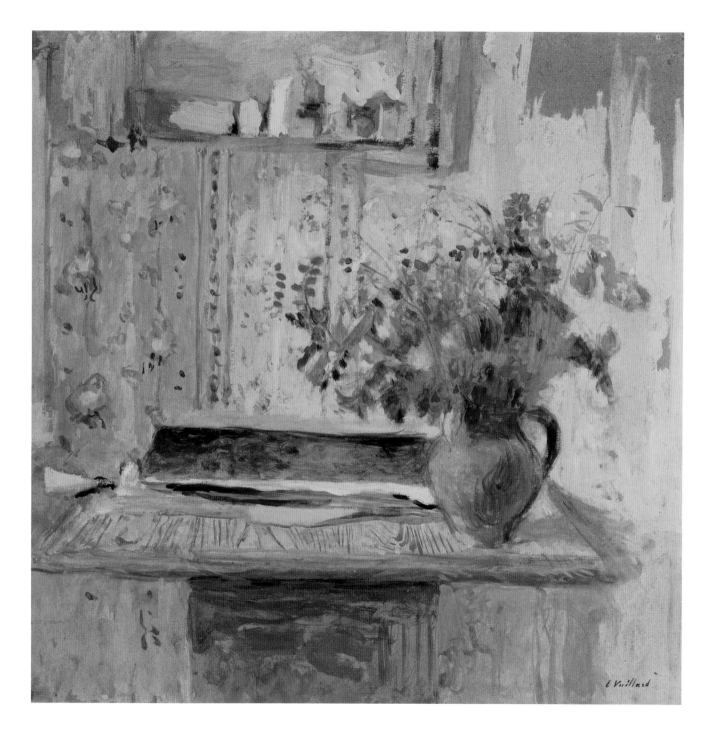

EDOUARD VUILLARD

67 *Remembrance of Romanel, near Lausanne,*
ca. 1900

Oil on cardboard, 36.8 x 35.9 (14$\frac{1}{2}$ x 14$\frac{1}{8}$)
Signed with estate stamp, lower left: *E. Vuillard*
Acc. no. 83.61

Vuillard stayed with Félix Vallotton and his wife at the Château of Romanel in the canton of Vaud, Switzerland, during the summer of 1900. Both artists executed a number of landscapes, often working side by side on the same motifs.

COLLECTIONS: Paul Vallotton (brother of Félix Vallotton), until 1968.

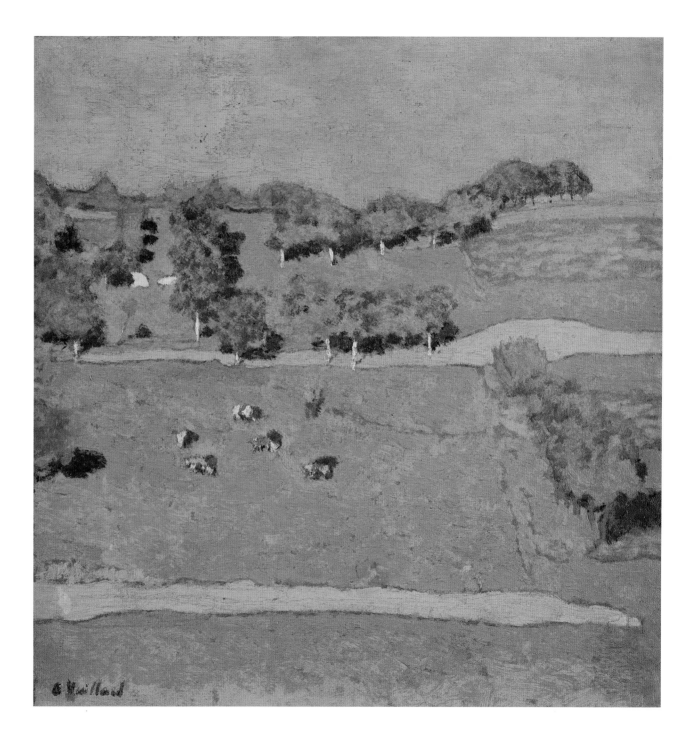

EDOUARD VUILLARD

68 *The Golden Chair*, 1906

Oil on panel, 67.9 x 66.6 (26³/₄ x 26¹/₄)
Signed and dated, lower right: *E. Vuillard 1906*
Acc. no. 84.4

Interior scenes with elevated viewpoints are not uncommon in Vuillard's work of 1904–06.

EXHIBITIONS: *French Paintings from the Collections of Mr. and Mrs. Paul Mellon and Mrs. Mellon Bruce*, National Gallery of Art, Washington, D.C., March 17–May 1, 1966, no. 189 (illus.).

COLLECTIONS: Private collection, Switzerland. Leigh Block, Chicago. Wildenstein & Co., New York, until 1959.

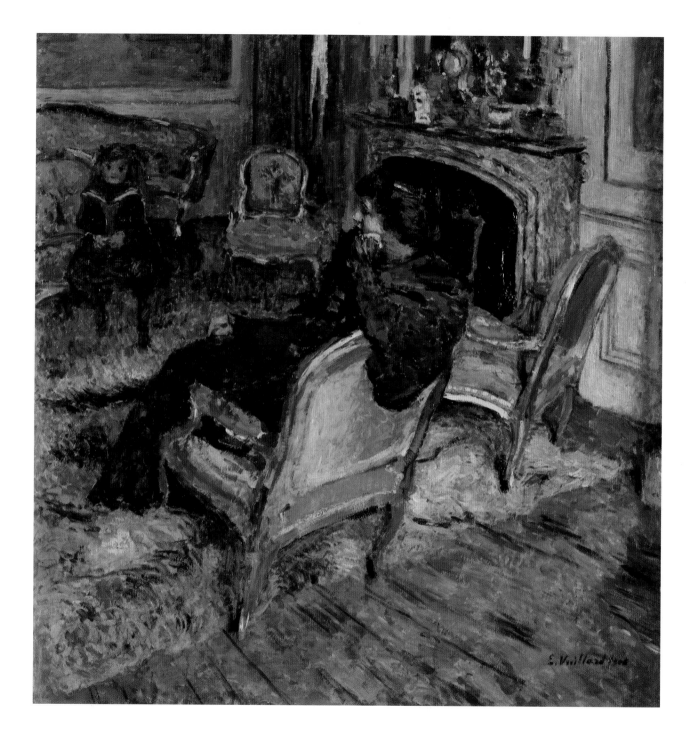

EDOUARD VUILLARD

69 *The Artist's Mother in Her Apartment,*
Rue de Calais, Paris—Morning, ca. 1922

Oil on millboard, 43.5 x 29.8 (17⅛ x 11¾)
Signed, lower right: *E. Vuillard*
Acc. no. 83.60

Vuillard's mother, with whom he lived until her death, owned a dress-
making shop in Montmartre. She was a frequent subject of her son's
work. The rue de Calais is a short street leading away from the former
Place Vintimille (today, Place Adolphe Max), which is a short distance
south of the Montmartre cemetery.

REFERENCES: Claude Roger Marx, *Vuillard et son temps* (Paris, 1946), illus. opp. p.
120. J. Salomon, *Vuillard admiré* (Paris, 1961), p. 142 (illus.).

EXHIBITIONS: *Vuillard*, 1954, p. 103: Cleveland Museum of Art, Jan. 26–March
14; The Museum of Modern Art, New York, April 7–June 6. *French Paintings from
the Collections of Mr. and Mrs. Paul Mellon and Mrs. Mellon Bruce*, National Gallery
of Art, Washington, D.C., March 17–May 1, 1966, no. 191 (illus.).

COLLECTIONS: Jacques Laroche. Dr. F. Schoni, Zurich, until 1965.

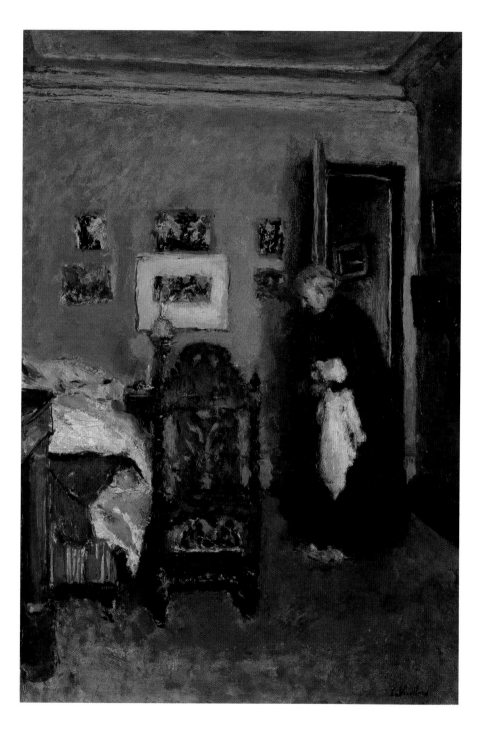

INDEX OF ARTISTS

OTHER CATALOGUES OF THE COLLECTIONS OF
THE VIRGINIA MUSEUM OF FINE ARTS

Fabergé: A Catalog of the Lillian Thomas Pratt Collection of Russian Imperial Jewels (1960; rev. 1976)

European Art in the Virginia Museum (1966)

Ancient Art in the Virginia Museum (1973)

Treasures in the Virginia Museum (1974)

The Sydney and Frances Lewis Contemporary Art Fund Collection (1980)

Eighteenth-Century Meissen Porcelain from the Margaret M. and Arthur J. Mourot Collection in the Virginia Museum of Fine Arts (1983)

Oriental Rugs, The Collection of Dr. and Mrs. Robert A. Fisher in the Virginia Museum of Fine Arts (1984)

British Sporting Paintings, The Paul Mellon Collection in the Virginia Museum of Fine Arts (1985)

Late 20th-Century Art, Selections from the Sydney and Frances Lewis Collection in the Virginia Museum of Fine Arts (1985)

Late 19th and Early 20th Century Decorative Arts, The Sydney and Frances Lewis Collection in the Virginia Museum of Fine Arts (1985)

The Virginia Museum of Fine Arts wishes to acknowledge the assistance and cooperation of Beverly Carter, Administrative Assistant, Paul Mellon Collection.

This book was composed in Linoterm Sabon by Meriden-Stinehour Press, of Meriden, Connecticut, and Lunenburg, Vermont, and printed on Consolidated's acid-free Centura Dull Enamel by Whittet & Shepperson of Richmond, Virginia.